IMAGES
of America

THE OKLAHOMA
MUSIC TRAIL

CW00952032

ON THE COVER: Bob Wills and His Texas Playboys are pictured at Cain's Ballroom in Tulsa, Oklahoma, around 1935. For more information, see page 92. (Author's collection.)

IMAGES
of America

THE OKLAHOMA
MUSIC TRAIL

Karl Anderson

ARCADIA
PUBLISHING

Copyright © 2023 by Karl Anderson
ISBN 978-1-4671-0927-7

Published by Arcadia Publishing
Charleston, South Carolina

Printed in the United States of America

Library of Congress Control Number: 2022944862

For all general information, please contact Arcadia Publishing:
Telephone 843-853-2070
Fax 843-853-0044
E-mail sales@arcadiapublishing.com
For customer service and orders:
Toll-Free 1-888-313-2665

Visit us on the Internet at www.arcadiapublishing.com

LORRIE COLLINS. This book is dedicated to Lorrie Collins (1942–2018). She was a native of Oklahoma. When Lorrie was eight years old, she won a talent contest hosted by Leon McAuliffe at the Cimarron Ballroom in Tulsa. McAuliffe urged Lorrie's parents to leave Oklahoma to pursue a music future for their children in Louisiana or California. In 1953, the Collins family moved to Long Beach, California. By 1954, Lorrie and her younger brother Larry were regular performers on *Town Hall Party*, a weekly television show broadcast from Compton. The Collins Kids recorded and toured throughout America and overseas. Larry was a guitar prodigy and songwriter. Lorrie was a dynamic and photogenic singer who became the darling of the rockabilly generation. (Courtesy of Larry Collins.)

CONTENTS

ACKNOWLEDGMENTS

I would like to extend my appreciation to several friends who helped make this book possible. Memorabilia includes contributions from my friends Larry Collins, Marilyn Tuttle, Linda Dotson-Wooley, Sherry Bond, Jody Maphis, and Shari Penny. Country music fans from England Volker Houghton and Noel Thibault shared dozens of vintage photographs and *Billboard/Cash Box* magazine advertisements.

Joni Twitty shared wonderful stories about the life and times of her father, Conway Twitty. Betsy Brumley contributed rare family pictures and stories about her grandfather, the legendary gospel songwriter Albert E. Brumley Sr. Theresa Knox provided a beautiful photograph of the Church Studio. She was extremely informative about the history and restoration of her building.

My daughters, Karla Anderson and Anna Kristina Anderson, helped edit my text and photograph selection. Karla also photographed framed posters, images, and memorabilia from my collection.

Unless otherwise noted, all of the images are from the author's collection.

INTRODUCTION

The Oklahoma Music Trail is a photo essay about the larger-than-life and nearly forgotten singers, musicians, and songwriters who were born, raised, or lived in Oklahoma. Some of these artists have entertained America since the early 1930s. The state is home to contemporary country music celebrities such as Garth Brooks, Carrie Underwood, Vince Gill, Reba McEntire, Blake Shelton, and Toby Keith.

This book focuses on country music performers and songwriters who have left center stage or have otherwise been marginalized and forgotten in time. It is important to remember there are many other artists who have enriched lives and deserve our recognition. You are invited to journey along the highways and byways where legendary entertainers once lived and performed. Hopefully, this book will inspire you to explore and enjoy the music heritage of Oklahoma.

One

THE SINGING COWBOYS

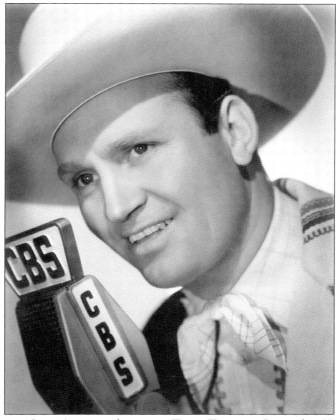

GENE AUTRY. Orvon Gene Autry was born near Tioga, Texas, on September 29, 1907, to Delbert and Elnora Ozment Autry. As a five-year-old, he sang in his grandfather's church. Later, he learned to play a guitar purchased from Sears Roebuck. While attending high school, Gene worked part-time for the railroad to help support his family. He left school during his last year to become a full-time employee with the promise of more income. Gene worked his way up to relief telegrapher for the St. Louis & San Francisco Railway, filling in at various town depots—among them Chelsea. One day, Will Rogers walked into the telegraph office and heard Gene singing and playing his guitar. Rogers was impressed and encouraged Gene to pursue a music career; this was a turning point in Gene's life. By 1929, Gene secured a time slot on radio station KVOO in Tulsa as "Oklahoma's Yodeling Cowboy." The program had a large radio audience that helped Autry obtain a recording contract with Columbia Records. In 1930, he joined the *National Barn Dance* on radio WLS in Chicago. In 1931, Gene and fellow musician Jimmy Long wrote and recorded their composition of "That Silver Haired Daddy of Mine." The record sold more than a million copies. Gene Autry became the first artist to have a certified gold record. (Courtesy of Gene Autry Entertainment.)

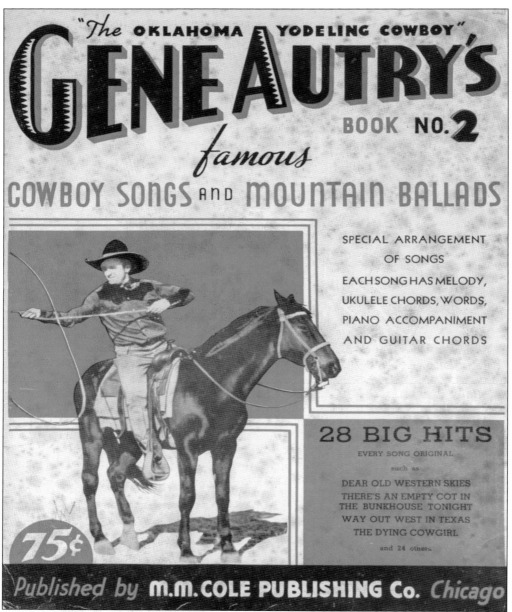

GENE AUTRY "OKLAHOMA YODELING COWBOY" SONG BOOK NO. 2. On April 1, 1932, Gene Autry married Ina Mae Spivey (1911–1980), Jimmy Long's niece. In 1934, Autry, Ina, and Smiley Burnette traveled to Los Angeles, where Gene appeared in the Ken Maynard movie *In Old Santa Fe*. In 1935, Gene had his first starring role in *The Phantom Empire*, a Republic Pictures production. Although Autry was not the first singing cowboy, he helped to popularize the new movie genre when he starred in *Tumbling Tumbleweeds* in 1935. In 1938, Gene formed the *Flying A Rodeo*, a Western music show and rodeo that toured throughout the United States. In 1941, Autry built the Flying A Ranch near Berwyn, Oklahoma, as a home for his rodeo. Although Gene did not move to Berwyn, the town officially petitioned to change its name to Gene Autry, Oklahoma. Today, the town's major attraction is the Gene Autry Oklahoma Museum.

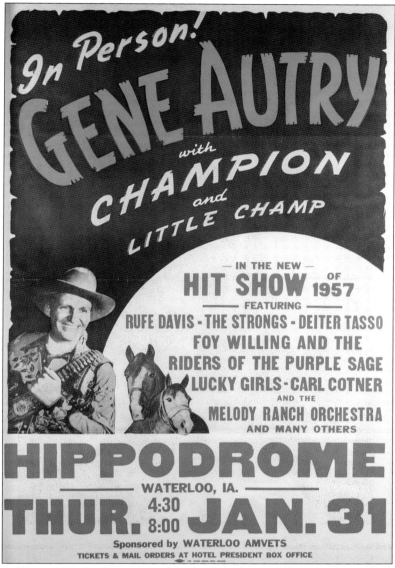

GENE AUTRY POSTER. Gene Autry started his *Melody Ranch* radio program in 1940. The show did not end when Autry joined the US Army Air Corps in 1942. It was renamed *Sgt. Gene Autry* for a series of episodes. He became a pilot in the Pacific theater and flew the Burma "Hump." After World War II, Autry continued to host the *Melody Ranch* radio show (until 1956). Under the Flying A Pictures banner, Gene produced *The Gene Autry Show, Annie Oakley, Champion,* and *Range Rider* television serials, among others. Gene Autry appeared in 93 movies, made 640 recordings, and wrote or cowrote more than 300 songs. He became known as the "America's Favorite Singing Cowboy." Autry was the first performer to sell out New York's Madison Square Garden. His recording of "Rudolph the Red-Nosed Reindeer" became the second most popular Christmas song of all time and sold more than 30 million copies. Autry sold more than 100 million records, including a dozen gold and platinum releases, during his career. In later years, Gene Autry owned radio and television stations in Los Angeles and other cities in the United States, along with hotels and other business interests.

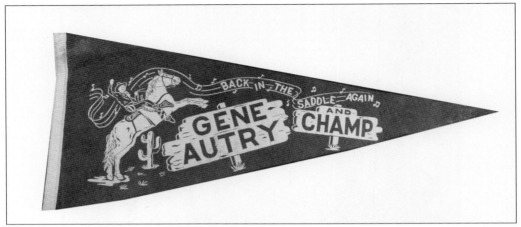

GENE AUTRY PENNANT. In 1961, he became the original franchise owner of the Angels major-league baseball team. In 1988, he opened the Autry Museum of the American West in Los Angeles. The Autry's diverse collections include more than 600,000 artifacts, artworks, and archival materials that reflect the interconnectedness of cultures and histories in the American West. Gene Autry died of lymphoma at his home in Studio City, California, on October 2, 1998. He was survived by his second wife, Jackie. Gene Autry was a 33-degree Mason.

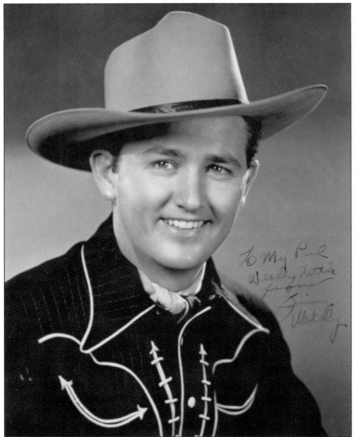

JIMMY WAKELY. James Clarence Wakeley, also known as Jimmy Wakely, was born on February 16, 1914, to Maj. Anderson and Caroline "Cali" Burgess Wakeley in Mineola, Arkansas. By 1920, the family moved to Rosedale, Oklahoma. After winning a talent contest, Wakely decided to pursue a career in music. In 1935, he married Dora Inez Miser (1917–1997). In 1937, Jimmy formed the Bell Boys, a Western music group named after their sponsor, Bell Clothing. They performed locally and broadcast on radio WKY in Oklahoma City. Johnny Bond, Dick Reinhart, and Scotty Harrell were the other members of the group. (Courtesy of Marilyn Tuttle.)

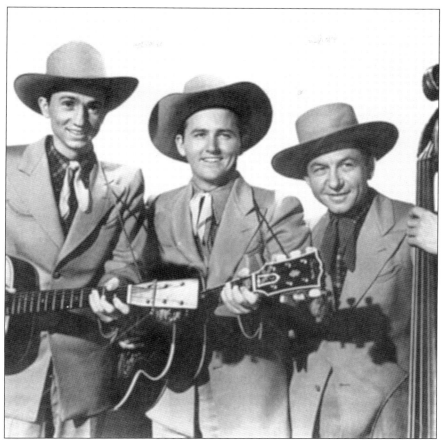

THE BELL BOYS. During the late 1930s, Gene Autry came to Okemah, Oklahoma, and Lawrence, Kansas, to promote his new movie *Rancho Grande*. The Bell Boys (also known as the Jimmy Wakely Trio) attended both events. They talked their way into meeting Autry, who thought the group would be a good addition to his new *Melody Ranch* radio show, originating from Hollywood, California. In 1939, the Jimmy Wakely Trio made their film debut in *Saga of Death Valley*, starring Roy Rogers. On May 31, 1940, Jimmy and Inez Wakely and their two daughters, Johnny and Dorothy Bond, and Dick Reinhart left Oklahoma City for California. By mid-1940, the Wakely Trio joined the *Melody Ranch* radio show. In 1941, Jimmy signed a recording contract with Decca Records. By 1942, Wakely left *Melody Ranch* to appear in B Western motion pictures. From 1944 to 1949, Jimmy Wakely appeared in 28 B Westerns for Monogram Pictures. In 1946, he was featured in his most popular film, *Song of the Sierras*. Jimmy was known as a low-budget Gene Autry in films. Wakely once remarked that "everybody reminds somebody of someone else until they are somebody. And I had rather be compared to Gene Autry than anyone else. Through the grace of God and Gene Autry, I got a career." Jimmy rode a horse named Lucky in most of his Western films. In 1948, Lucky was given away as a prize to a participant on the *Queen for a Day* radio program. It seems that Wakely had been looking for a special horse. His name was Sonny. According to a tidbit from the press book for *Oklahoma Blues* (Monogram Pictures, 1948), Jimmy said, "The horse has four white feet. Notice the blaze in his face and the bright, rich color, and you are looking at my dream for the right horse come true." By today's standards, giving Lucky to a complete stranger on a radio program seems the equivalent of abandoning a child to an unknown passenger on a New York subway; however, 75 years ago, a horse would have been considered livestock rather than a family member. (Courtesy of Bob "Boppin Bob" Jones.)

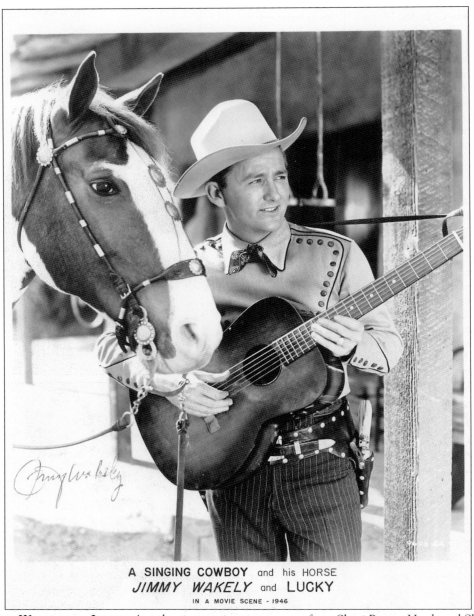

A SINGING COWBOY and his HORSE
JIMMY WAKELY and LUCKY
IN A MOVIE SCENE - 1946

JIMMY WAKELY AND LUCKY. Another interesting story comes from Shari Penny. Hank and Shari Penny were friends of Jimmy and Inez Wakely. Shari remembers that Jimmy enjoyed creating his own publicity. While dining at Los Angeles restaurants such as the Brown Derby or Beverly Hills Hotel, Wakely would have himself paged so that guests and patrons might hear his name. Wakely was the composer or cowriter of more than a hundred songs. His favorite composition was "Saddle Pals," a song he sang in his first feature film, *Song of the Range*, in 1944. In 1947, Wakely signed a recording contract with Capitol Records. He recorded several successful singles with Margaret Whiting, including "One Has My Name (the Other Has My Heart)," which reached No. 1 on the country charts in 1948, and "Slippin' Around," which was a No. 1 hit on the country music and pop music charts in 1949. Another No. 1 hit for Wakely was "I Love You So Much It Hurts" in 1949.

14

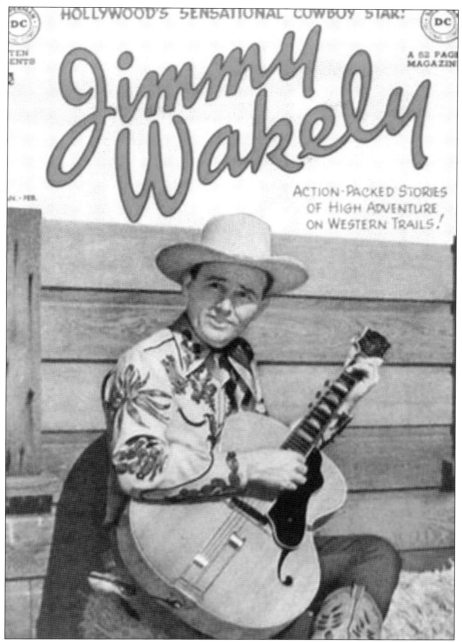

JIMMY WAKELY COMIC BOOK. Pictured here is the cover of *Jimmy Wakely* No. 3, released by DC Comics on January 1, 1950. From 1949 to 1952, Jimmy had his own comic book series. DC Comics published 18 issues. Wakely was billed as "Hollywood's Sensational Cowboy Star." In 1952, Wakely was the host of *Hollywood Barn Dance*, broadcast by CBS in Hollywood, California. The program eventually became *The Jimmy Wakely Show* and ended in 1958. During the mid-1960s, Jimmy started a recording company called Shasta Records. Jimmy Wakely developed emphysema and died of heart failure at Mission Hills, California, on September 23, 1982. Jimmy was survived by his wife, Inez, and their four children.

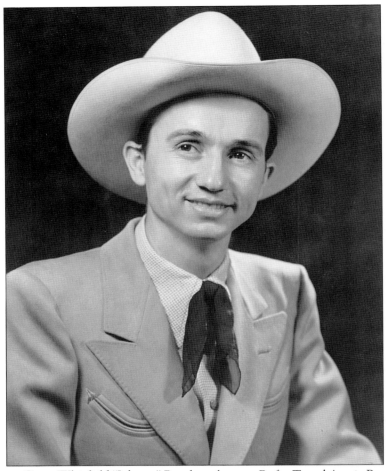

JOHNNY BOND. Cyrus Whitfield "Johnny" Bond was born to Rufus T. and Annie Bond on June 1, 1915, in Enville, Oklahoma. As a result of his birth, the town's population grew to 50. The family moved to Marietta, Oklahoma, where he attended school. As a teenager, Johnny purchased a ukulele and a *How to Play the Ukulele in Five Minutes* instruction book from a Montgomery Ward catalog for 98¢. A week later, Johnny had learned to play the instrument. After high school, Johnny moved to Oklahoma City to live with his brother Howard, who helped him obtain a job playing guitar at the Criterion Theater. In the meantime, Johnny began knocking on the doors of local radio stations. He was "hired" by radio KFXR to perform for no pay. He went on to play with Billy McGinty's Oklahoma Cowboys, which was later known as Pop Moore and His Oklahomans. In the meantime, Johnny met Jimmy Wakely and Scotty Harrell. He became a member of the Bell Boys, a group sponsored on the radio by Bell Clothing. They performed on radio WKY in Oklahoma City. As previously mentioned, Gene Autry traveled to Oklahoma and Kansas to promote a new movie. The Bell Boys attended both events and talked their way into meeting Autry. Their meeting resulted in an invitation to perform on *Melody Ranch*, Autry's new radio show originating from Hollywood. Johnny and Dorothy Bond left Oklahoma City for California in May 1940. Bond appeared on the original *Melody Ranch* show from 1940 until it ended in 1942. *Hollywood Barn Dance* was the replacement program for *Melody Ranch*. Bond was a cast member of the show from 1943 until it ended in 1952. The show featured Cottonseed Clark, Foy Willing and the Riders of the Purple Sage, Merle Travis, and other great performers from that era. (Courtesy of Sherry Bond.)

JOHNNY BOND AT THE
HOLLYWOOD BARN DANCE.
Johnny Bond began recording
with Columbia Records in
1937. From 1939 to 1947, he
appeared in 38 B Western
films with Gene Autry, Johnny
Mack Brown, Tex Ritter,
and Roy Rogers. Bond was
usually featured as a sidekick
or guitar player. He was a
member of Tex Ritter's band,
the Red River Valley Boys, on
tours and recording sessions.
Ritter and Bond formed Vidor
Music, a publishing company.
(Courtesy of Sherry Bond.)

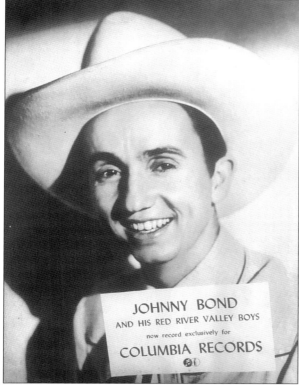

JOHNNY BOND COLUMBIA RECORDS
AD. Bond was a cast member of
Town Hall Party (1953–1960) and the
Melody Ranch television show (1964–
early 1970s). He was an accomplished
actor, author, comedian, guitar
player, and songwriter. His
compositions included "Cimarron,"
"I Wonder Where You Are Tonight,"
"Ten Little Bottles" (a No. 2 country
hit in 1965), "Tomorrow Never
Comes," and more than 127 songs by
1957. Bond wrote an autobiography
for the John Edwards Memorial
Society and a biography of Tex
Ritter. (Courtesy of Sherry Bond.)

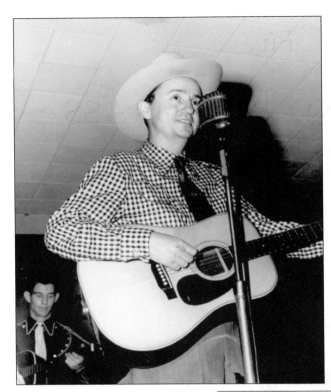

JOHNNY BOND SINGING AT TOWN HALL PARTY. During the 1960s, Gene Autry, Tex Ritter, and Johnny Bond served on the board of directors for the Country Music Association. During their tenure, the Country Music Hall of Fame was organized in Nashville. Bond died from a stroke on June 12, 1978. He was survived by his wife, Dorothy, and their two daughters. (Courtesy of Marilyn Tuttle.)

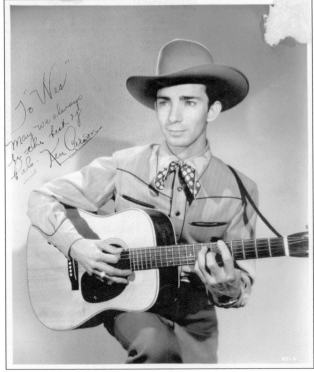

KEN CARSON. Hubert Paul Flatt, also known as Ken Carson (1914–1994), was born in Centrahoma, Oklahoma. He was an early member of the Sons of the Pioneers and appeared in 22 Roy Rogers movies. (Courtesy of Marilyn Tuttle.)

Two

WESTERN SWING

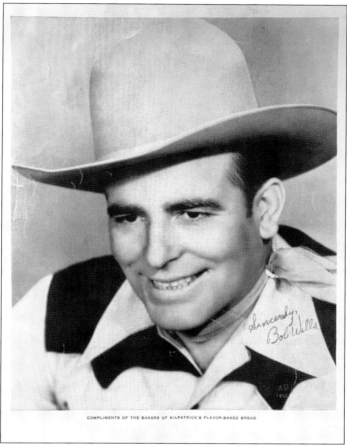

COMPLIMENTS OF THE BAKERS OF KILPATRICK'S FLAVOR-BAKED BREAD

BOB WILLS. James Robert "Bob" Wills was born on March 5, 1905, on a cotton farm in Kosse, Limestone County, Texas. He was one of eight children born to John Tompkins and Emma Lee Foley Wills. Bob's father was a state fiddle champion. "Jim Bob" learned to play fiddle and mandolin. Bob worked in the cotton fields during the day and played fiddle with the family band at night. In 1929, Bob moved to Fort Worth. He formed the Light Crust Doughboys along with Herman Arnspiger and Milton Brown. The group was sponsored by the Light Crust Flour Company. They performed on a daily radio program in Fort Worth while working full-time at the flour mill. In 1932, Tommy Duncan was hired to replace Milton Brown, who left the group to organize Milton's Brownies. Duncan was a piano player who became Wills's most famous singer. Wills was unable to get along with future Texas governor W. Lee "Pappy" O'Daniel, host of *The Light Crust Doughboy* radio show. O'Daniel despised hillbilly music and fired Wills on several occasions for excessive drinking. In 1933, Bob Wills left the group to form the Texas Playboys.

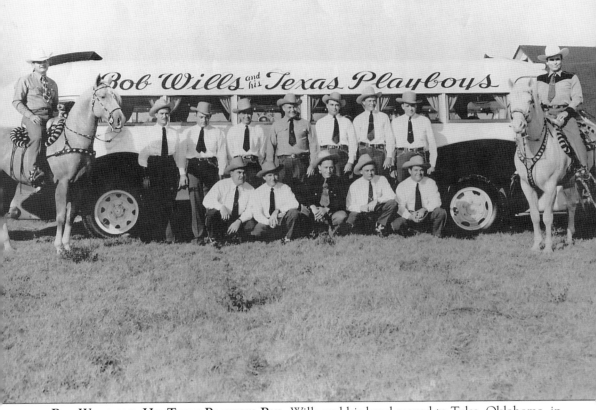

Bob Wills and His Texas Playboys Bus. Wills and his band moved to Tulsa, Oklahoma, in 1934. On February 9, 1934, Bob Wills and His Texas Playboys played a one-hour trial broadcast at midnight on radio station KVOO. The band was offered a daily radio show that lasted for a decade. The Texas Playboys began live broadcasts six days a week from Cain's Ballroom in Tulsa. By 1935, Bob added horns, reed instruments, drums, and steel guitar player Leon McAuliffe. In 1940, Bob Wills and His Texas Playboys released "New San Antonio Rose." The recording reached No. 11 on the *Billboard* charts and sold over a million records. From 1939 to 1946, Bob Wills and His Texas Playboys were featured in 19 films, including *Take Me Back to Oklahoma*, starring Tex Ritter. In 1942, the group disbanded when Wills and several band members enlisted in the Army. In 1943, Bob received a medical discharge from the Army. Wills moved to California, where he became extremely popular.

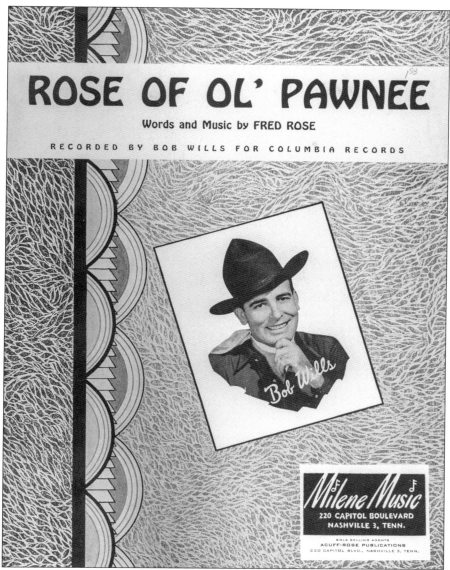

BOB WILLS PENNANT. By 1945, Bob Wills was drawing larger audiences than big band legends Tommy Dorsey and Benny Goodman. During the late 1940s, Wills was a binge drinker and became increasingly unreliable. This caused friction with Tommy Duncan, who was often the target of audience anger when Bob failed to appear due to drinking or hangovers. Wills fired Duncan during the fall of 1948. Eldon Shamblin offered a different perspective on Wills's drinking. In a YouTube video, Shamblin said that many Wills fans were also drinkers. Saying that Wills was sick would not satisfy an audience. But when Eldon would announce that Wills would not be appearing because he was drunk or recovering from a hangover, the crowd would cheer. In 1949, Wills moved to Oklahoma City. However, he continued touring to maintain his lifestyle and assets, which included his Wills Point resort. Wills made a huge mistake when he opened a second nightclub—the Bob Wills Ranch House in Dallas, Texas. The club was extremely mismanaged. Wills encountered financial problems, including a large IRS tax debt. He was forced to sell valuable assets, including copyrights to "New San Antonio Rose."

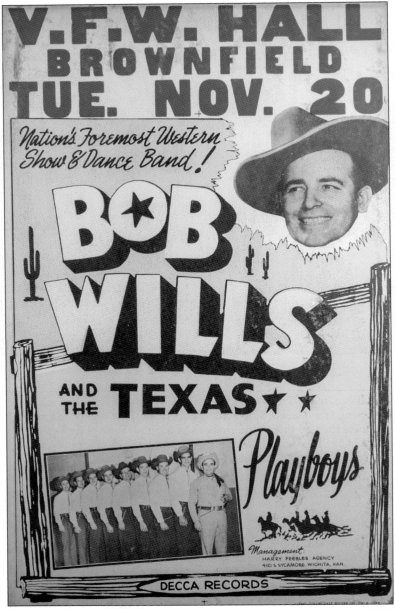

Bob Wills Poster. By the early 1950s, the big band era had come to an end. In 1956, Wills Point was destroyed by fire. He sold the remaining property and left California. Wills returned to Tulsa in 1957. However, rock and roll music had taken over America. Bob Wills and Western swing would never enjoy the popularity that they had known in Tulsa from the mid-1930s to the early 1940s. In 1962, Wills suffered a heart attack; he had another one the following year. This forced Bob to disband the Texas Playboys. Wills continued to perform, but his active career ended when became paralyzed by a stroke in 1969. In 1973, Wills recorded a tribute album that included Merle Haggard and the Texas Playboys entitled *For the Last Time*. On the night before the final session, Wills suffered a stroke that left him comatose until his death on May 13, 1975. Wills was married six times (twice to the same woman) and was survived by two children.

SPADE COOLEY. Donnell Clyde "Spade" Cooley was born on December 17, 1910, in Grand, Oklahoma, to John Wesley and Emma Porria Donnell Cooley. As a young boy, Donnell learned to play the fiddle. By the age of eight, he and his father performed at local dances. Donnell was one-quarter Cherokee and was sent to Chemawa School in Salem, Oregon. During this period, Native Americans were removed from their families for assimilation into traditional American culture. At the Indian boarding school, he studied cello and violin. In 1930, Donnell moved to Modesto, California, where he worked as a laborer during the day and played fiddle at night. He was known as a good poker player. One evening, Cooley drew a flush in spades on three consecutive rounds of poker. He became known as "Spade" Cooley. In 1934, Cooley moved to Southern California, where he met Leonard Slye, later known as Roy Rogers. The two became friends. Spade became a double in Rogers's B Western movies. Spade also performed with local groups including the Sons of the Pioneers, Jimmy Wakely Trio, and Riders of the Purple Sage. He became a favorite in recording sessions. Foreman Phillips (who was a promoter of Los Angeles–area country music barn dance programs) told Spade that he should form his own band. In 1942, he began appearing at the Venice Pier Ballroom. In 1943, he leased the 10,000-square-foot Riverside Rancho at Griffith Park in Los Angeles as a venue for his shows. In 1945, Spade recorded Smokey Rogers's composition of "Shame, Shame on You." It became the group's theme song. That year, Cooley divorced his first wife and married Ella Mae Evans. The couple had two children: Donnell Jr. and Melody. (Courtesy of Tyler Mahan Coe.)

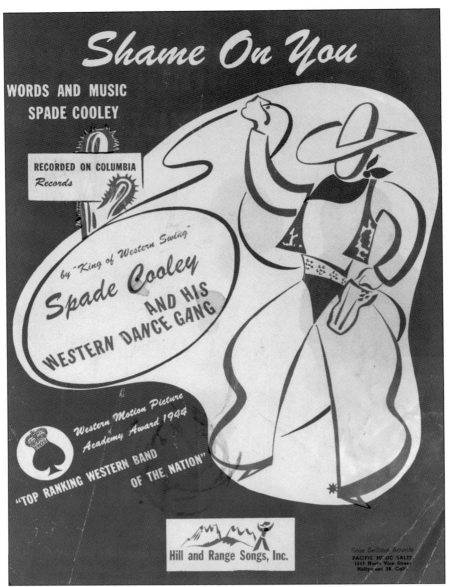

"SHAME ON YOU" SHEET MUSIC. Cooley became known as "the King of Western Swing." Hank Penny recalled that Spade was a dapper dresser who owned over 100 hand-tailored suits, 36 pairs of boots, and a yacht. His manager, Bobbie Bennett, said that Spade was very generous and wanted to please everyone; however, he had a troubled mind and was a jealous individual. In addition, Cooley was known as a womanizer and heavy drinker. He often became angry when drunk. From 1948 to 1957, Spade hosted a variety show on Los Angeles television station KTLA. Cooley, who was known as "Your Fiddlin' Friend," became a major entertainment personality in Los Angeles. It was reported that 75 percent of the televisions in the metropolitan area were tuned to *The Hoffman Hayride* every Saturday night. By the mid-1950s, rock and roll music was replacing Western swing and Spade's popularity. In 1958, he "retired" and began construction of a theme park called Water Wonderland in the Mojave Desert north of Los Angeles. During this period, he suffered a heart attack.

SPADE COOLEY PENNANT. Spade Cooley was also building his luxurious ranch in Willow Springs, California, and suffered a second heart attack. In the meantime, Spade and Ella Mae encountered marriage problems that became public. She had told a friend about an early-1950s affair with Roy Rogers. On April 3, 1961, a drunken Spade Cooley murdered his wife. After the longest and most notorious murder trial in Kern County history, Spade was convicted of murder. He withdrew his plea of insanity to avoid the death penalty. However, Cooley was sentenced to life in prison.

JAILHOUSE LETTER TO HANK PENNY. During his eight years at the California State Prison in Vacaville, Spade Cooley was a model prisoner and eventually admitted guilt. In 1969, Gov. Ronald Reagan granted parole for Cooley to take place in early 1970. A few months prior to his scheduled release from prison, He was granted permission to entertain for a benefit concert for the Alameda County Sheriff's Department. On November 23, 1969, Cooley received a standing ovation from an audience of 3,000. Spade suffered a fatal heart attack backstage in the arms of his son. Cooley's last words were reported, "I have the feeling that today is the first day of the rest of my life." (Courtesy of Shari Penny.)

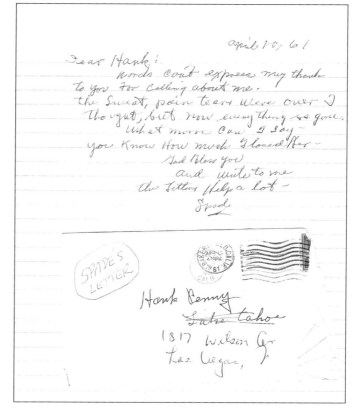

HANK THOMPSON. Henry "Hank" William Thompson was born on September 3, 1925, in Waco, Texas. He was the son of Jule Thomas and Zexia Ilda Wells Thompson. His paternal grandparents were Czechs named Kocek who changed their surname to Thompson. As a young child, Hank played harmonica. His parents gave him a $4 guitar for Christmas, and he learned to sing and play guitar like his hero, Gene Autry. Hank appeared in local talent shows as a teenager. He eventually performed on his own local radio program and became known as "Hank the Hired Hand." Hank graduated from high school and joined the Navy in 1943. He received training as a radio technician. Following his discharge from the Navy, he studied electrical engineering at Southern Methodist University, the University of Texas, and Princeton. However, Hank wanted to pursue a music career. He returned to Waco and formed a band called the Brazos Valley Boys. They quickly became a popular local act. In 1946, they recorded their first single, "Whoa Sailor" (a song Thompson wrote while in the Navy) for Globe Records. They recorded four sides for the Bluebonnet label before Tex Ritter helped Hank sign a contract with Capitol Records in 1947. (Courtesy of Marilyn Tuttle.)

HANK THOMPSON RECORDING. In 1951, Hank Thompson moved to Oklahoma City. He became the first country music performer to host his own television program. In addition, *The Hank Thompson Show* became the first variety show broadcast in color. In 1952, Thompson's recording of "The Wild Side of Life" became a No. 1 hit for more than three months and became his signature song. (Courtesy of Noel Thibault.)

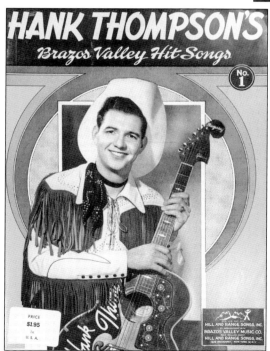

HANK THOMPSON SONGBOOK NO. 1. From 1948 to 1975, Hank Thompson released 29 top-10 hits and another 19 top-20 hits. The Brazos Valley Boys were voted by *Billboard* magazine as "Touring Band of the Year" for 14 consecutive years. Thompson sold more than 60 million records. His movie credits include *The Last Picture Show* (1971), *Slither* (2006), and *Keeping Up with the Joneses* (2016). With his background in electronics, Thompson became the first performer to tour with a sound and lighting system. He was also the first act to have a corporate tour sponsorship, record a live album (*Live at the Golden Nugget* in 1960), record in hi-fi stereo, and put on the first country music show to perform in Las Vegas.

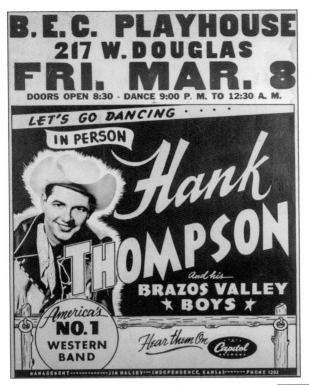

HANK THOMPSON POSTER. Hank Thompson was known for Western swing and honky-tonk music. His band featured fiddles and steel guitar. Guitar legend Merle Travis played on nearly all of Thompson's Capitol recordings. Thompson was married to Dorothy Ray. When they divorced, Dorothy married Merle Travis. Travis often referred to Thompson as his husband-in-law. Thompson died from lung cancer on November 6, 2007, in Keller, Texas. He was survived by his second wife, Ann Williams.

JOHNNIE LEE WILLS. Johnnie Lee Wills was born in 1912 in Jewel, Texas, and moved to Tulsa in 1934 as an original member of the Texas Playboys. When his brother Bob moved to California during the 1940s, Johnnie took over the radio programs at KVOO. He remained in Tulsa until his death in 1984. Johnnie Lee Wills Lane is directly in front of the Expo Square Pavilion at the Tulsa State Fairgrounds. At the dedication in 1996, his son John T. Wills said, "Although dad was born a Texan, when you think about it, he lived and died a Tulsan."

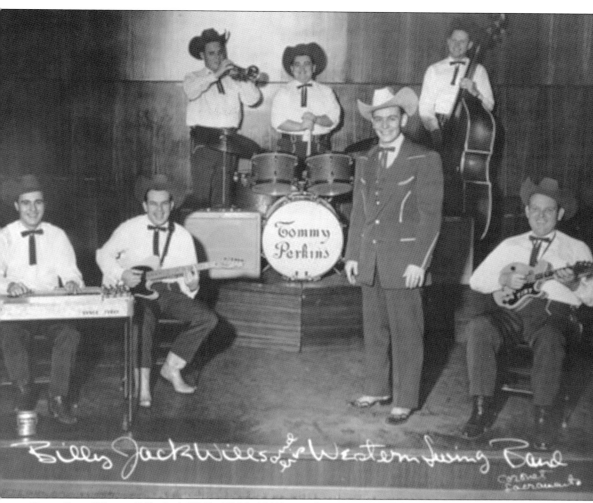

BILLY JACK WILLS. Billy Jack Wills (1926–1991) was the youngest of the four Wills brothers. He played bass and drums with the Texas Playboys during the 1940s. Billy Jack composed the lyrics to "Faded Love." When Bob departed from Wills Point Ballroom in Sacramento, Tiny Moore and he formed Billy Jack Wills and His Western Swing Band as the in-house entertainment. When rock and roll began to dominate, Billy Jack moved to Shawnee, Oklahoma, and worked as a plumber. (Courtesy of muleskinner.blogspot.com)

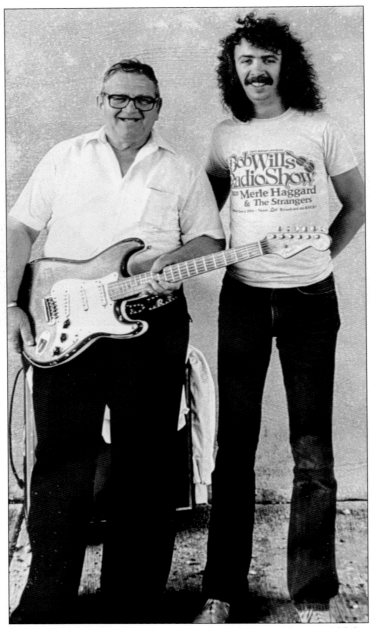

ELDON SHAMBLIN. Estel Eldon Shamblin (1916–1998) was born in Clinton, Oklahoma. From 1937 to 1959, he played guitar for Bob Wills and His Texas Playboys. Beginning in 1975, Shamblin played guitar with Merle Haggard and the Strangers. In 1983, he retired to Tulsa. He continued to perform and record locally while operating a convenience store. Shamblin is considered one of the greatest rhythm guitar players of all time. He was known for his bass lines and changing chords with virtually every beat. The image of Shamblin (left) and Jody Maphis was taken at the Bob Wills live KVOO radio show at Cain's Ballroom featuring Merle Haggard and the Strangers. Shamblin is holding the gold Stratocaster presented to him by Leo Fender in 1954. (Courtesy of Jody Maphis.)

Three

POSTWAR COUNTRY

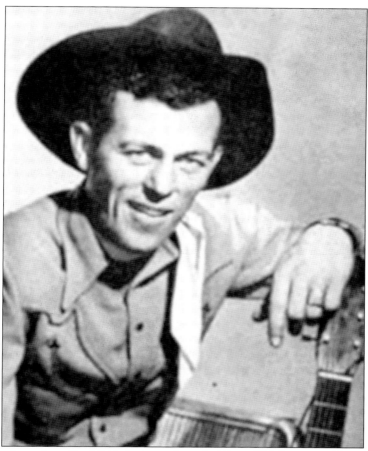

JACK GUTHRIE. Leon Jerry "Jack" Guthrie was born in Olive, Oklahoma, on November 13, 1915. The family moved to Texas in 1924 but returned to Sapulpa, Oklahoma, in 1929. Guthrie was raised around horses and music. He loved the cowboy life. His sister Wava claimed that Gene Autry taught guitar chords to her brother. During the mid-1930s, the family moved to Sacramento, California. Guthrie became known as "Jack," "Oklahoma," and "Oke." He competed as a rodeo bronc rider. In 1934, Guthrie married Ruth Henderson, and the couple sang and entertained in nightclubs. Jack performed trick roping and used a bullwhip to remove items from Ruth's hands and cigarettes from her mouth. Ruth grew tired of the scars and quit the act. In 1937, Jack moved to Los Angeles with his cousin Woody Guthrie. They performed as *The Oke and Woody Show* on station KFVD in Hollywood. During this period, Woody wrote "Oklahoma Hills," a song they sang on the show. Jack soon left the show and performed in clubs as "Oklahoma's Yodeling Cowboy." (Courtesy of Bob "Boppin Bob" Jones.)

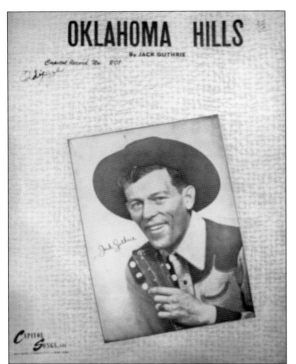

OKLAHOMA HILLS SHEET MUSIC. In October 1944, Jack Guthrie recorded a demo of "Oklahoma Hills." Capitol released the recording in 1945. The song reached No. 1 and remained on the charts for 19 weeks. The other side, "I'm A Brandin' My Darlin' With My Heart," reached No. 5. During this time, Guthrie was serving with the Army as a special services entertainer on Iwo Jima. Upon discharge from the Army, Guthrie performed around the West Coast. In 1946, "Oakie Boogie" reached No. 3 on the charts. In the meantime, Woody Guthrie realized the success of "Oklahoma Hills" and claimed ownership. The copyright was eventually changed to Jack Guthrie and Woody Guthrie. (Courtesy of Capitol Songs, Inc.)

JACK GUTHRIE IN *HOLLYWOOD BARN DANCE*. In 1947, Jack Guthrie experienced health issues and was diagnosed with tuberculosis but refused to recognize the seriousness of his condition. He organized a band and began touring. Guthrie said, "Right now, I'm hot and I've got to keep making personal appearances." He soon divorced and began drinking. In the meantime, he caught the attention of Ernest Tubb and appeared on *Grand Ole Opry*. He also sang "Oakie Boogie" in Tubb's movie *Hollywood Barn Dance*.

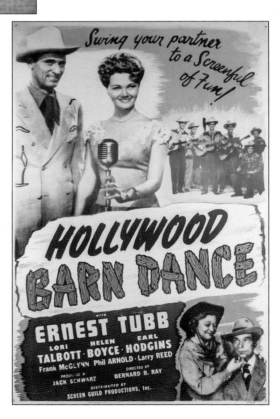

JACK GUTHRIE PLAYING GUITAR. In July 1947, he entered a tuberculosis sanatorium in Livermore, California. At the request of Capitol Records, Jack Guthrie traveled to Los Angeles in October and November 1947. Guthrie was extremely weak. He sat in a chair while recording and lay on a bed between sessions while recording 33 songs. Guthrie died in Livermore Hospital on January 15, 1948. Today, Jack Guthrie is best known as the cousin of Woody Guthrie. However, he was an important country singer during the mid-1940s. Jack sold more records than Woody and was commercially more successful than his cousin. In *The Journal of Country Music* Volume 15, he is remembered as a "Star That Almost Was." (Courtesy of Gerard "Rocky" Lambert.)

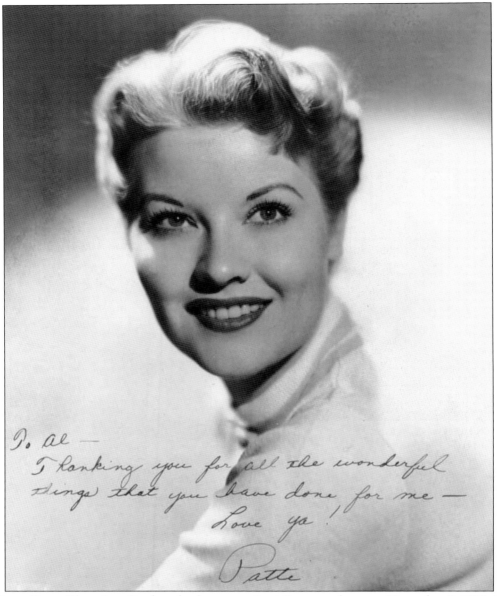

To Al —
Thanking you for all the wonderful
things that you have done for me —
Love ya !
Patti

PATTI PAGE. Clara Ann Fowler, also known as Patti Page, was born on November 8, 1927, in Claremore, Oklahoma. She was the second youngest of 11 children. Her father worked on the Midland Valley Railroad. Clara often played barefoot in the field alongside her mother and older sisters as they picked cotton. She commented later in life that "my father was a laborer on the railroad. We lived in section houses—the railroad gave section houses to the foreman and his crew. Sometimes they were good section houses and sometimes they were bad, but they were all poor. We had our own garden and my mother had a cow and a pig—that's how we ate. We had meat with our Sunday dinner, but we had a lot of cornbread and milk for supper during the week." From Clara's earliest recollections, music was an important part of her life. The Fowler Sisters sang at church and later on local radio shows. In 1945, she graduated from Daniel Webster High School in Tulsa and wanted to pursue an art career. (Courtesy of Noel Thibault.)

Tennessee Waltz

By REDD STEWART and PEE WEE KING

RECORDED BY PATTI PAGE FOR MERCURY RECORDS

Featured by PATTI PAGE

PUBLISHED BY
Acuff-Rose PUBLICATIONS
2510 FRANKLIN ROAD
NASHVILLE 4, TENNESSEE
MADE IN U.S.A.

"THE TENNESSEE WALTZ" SHEET MUSIC. In the meantime, Fowler started singing with Al Clauser and his Oklahoma Outlaws on KTUL in Tulsa. In 1945, she became a featured performer on a 15-minute radio program sponsored by the Page Milk Company. As a gesture to the program sponsor, Clara became known as "Patti Page." In 1946, Page toured with the Jimmy Joy Band. The band traveled to Chicago, where she sang with the Benny Goodman Septet. In 1947, Patti signed a contract with Mercury Records. In 1952, "The Tennessee Waltz" was No. 1 on the *Billboard* best-seller chart for 13 weeks. The record sold more than 10 million copies and remains the biggest selling single ever sold by a female artist. From 1950 to 1965, Page released 15 singles that sold more than a million copies. She sold more than 100 million records during her career.

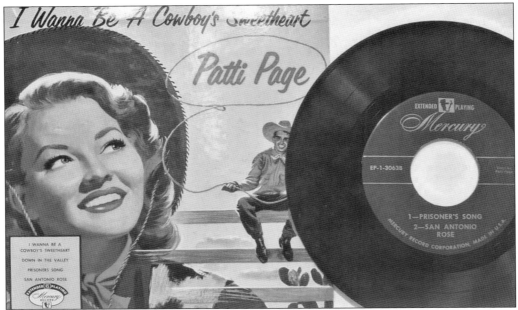

"I WANNA BE A COWBOY'S SWEETHEART." Page was a recording pioneer in overdubbing and the use of multiple voice techniques. She became known as "the Singing Rage, Miss Patti Page." Patti was originally known as a popular recording artist. However, she also had several country music and crossover hits. Some of her hit records included "Mockin' Bird Hill" (1951), "I Went To Your Wedding" (1952), "How Much Is That Doggie in the Window" (1952), "Allegheny Moon" (1956), "Old Cape Cod" (1957), and "Hush, Hush Sweet Charlotte" (1965). (Courtesy of Noel Thibault.)

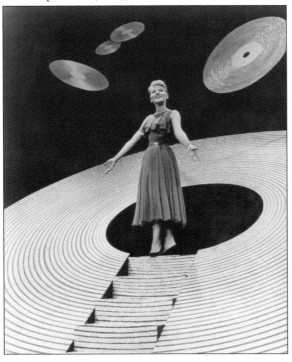

PATTI PAGE SURROUNDED BY FLYING SAUCERS. Page is the only singer to have had television programs on each of the three major networks. *The Patti Page Show* was nominated for an Emmy in 1959. She also appeared in numerous movies, including *Elmer Gantry* and *Blue Hawaii*. Page was quoted as saying, "I was a kid from Oklahoma who never wanted to be a singer, but was told I could sing. And things snowballed." Page died of heart and lung disease at a retirement home in Encinitas, California, on January 1, 2013. She was married three times and had two adopted children. (Courtesy of Noel Thibault.)

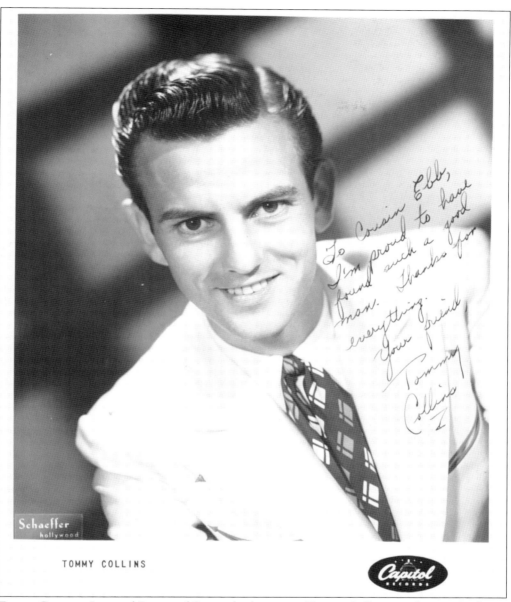

To Cousin Ebbs, I'm proud to have found such a good man. Thanks for everything. Your friend Tommy Collins

TOMMY COLLINS

TOMMY COLLINS. Leonard Raymond Sipes, also known as Tommy Collins, was born in Bethany, Oklahoma, on September 28, 1930. He was the youngest of six children born to Leslie Raymond and Willie Etta Brown Sipes. His father worked on the family farm and for the county as a road worker. From an early age, Leonard listened to Jimmie Rodgers and Ernest Tubb. His mother encouraged Leonard to write songs and play guitar. Sipes graduated from high school in 1948 and attended Edmond State Teachers College. He entered talent contests and occasionally sang on cousin Jay Davis's radio show on KLPR in Oklahoma City. In 1951, Leonard won a talent contest at KLPR that led to a regular radio show. He caught the attention of the Morgan Brothers, who were visiting from Fresno, California. The brothers heard Sipes singing with his band the Rhythm Okies. They offered to record Sipes at a studio in Oklahoma City and produced four songs. (Courtesy of Henry Harrison.)

TOMMY COLLINS RECORD ADVERTISEMENT. During the early 1950s, Leonard Sipes was living in Bakersfield, California. Terry Preston (also known as Ferlin Husky) and Sipes became friends and roommates. Husky recorded a few of Sipes's songs and encouraged Capitol Records to offer Sipes a recording contract. In June 1953, Sipes signed a contract with Capitol. Ken Nelson, the record producer for Capitol, suggested that Sipes change his name. During a Ferlin Husky recording session, Sipes left the studio to buy food and drinks for the musicians. One of the drinks ordered was a Tom Collins. Husky decided that Sipes should be called Tommy Collins. Collins formed a band that featured Buck Owens on lead guitar. In 1954, Collins had his first hit record, "You Better Not Do That." The song was No. 2 on the charts for seven weeks. He continued to write novelty songs. He wrote "If You Ain't Lovin' (You Ain't Livin')," a song that became a hit for Faron Young in 1954 and George Strait in 1988. (Courtesy of *Billboard* magazine.)

TOMMY COLLINS WITH A FAN. By 1956, Tommy Collins had a religious conversion. In 1957, Collins and his family moved to Oakland, California, where he attended Golden State Baptist Seminary. Two years later, he became an ordained minister. Collins became a pastor in Colfax, California. However, he continued to record for Capitol until 1960. In 1963, Collins left the ministry and returned to Bakersfield. He briefly recorded for Capitol. With help from Johnny Cash, Collins signed a contract with Columbia. In 1965, he had a top-10 hit with "If You Can't Bite, Don't Growl." By the early 1970s, Collins was addicted to drugs and alcohol. In 1971, his singing partner and wife, Wanda, divorced him. Tommy fell into depression. During this period, Merle Haggard recorded many of his songs, including No. 1 hits "Carolyn" (1972) and "Roots of My Raising" (1976). (Courtesy of Jeff Jackson.)

Swede's Shor-Vu Club

596 So. Norfolk, San Mateo

"Live it up at Swede's Tonite!"

Giant

Thanksgiving Dance and Party

TONITE — 9:30 A.M. to 1:30 A.M.

Featuring

Tommy Collins and Orchestra

Direct from
Las Vegas

NO COVER CHARGE

Phone DI 4-9349 for Reservations

Your Hostess: Your Host:

Donna Hillstead Swede (A. L.) Hillstead

TOMMY COLLINS PERFORMING AT SWEDE'S CLUB. In 1976, Tommy Collins moved to Nashville to become a songwriter for Sawgrass, a publishing company owned by Mel Tillis. In 1993, he was signed as a songwriter for Ricky Skaggs Music. Collins wrote more than 800 songs during his career and is credited as a pioneer of the Bakersfield Sound. Collins died at his home in Ashland City, Tennessee, on March 14, 2000, of complications from emphysema. (Courtesy of *Billboard* magazine.)

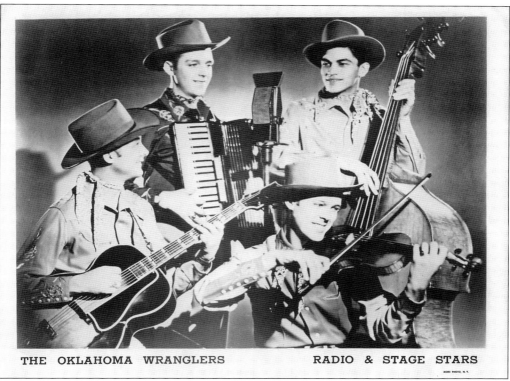

THE OKLAHOMA WRANGLERS RADIO & STAGE STARS

OKLAHOMA WRANGLERS. The Oklahoma Wranglers originally included James Willis, Charles Willis, and Webb "Robber Baron" Cardwell. They performed from the early 1930s as the Oklahoma Wranglers and were regulars on radio station KGFE in Shawnee, Oklahoma. Webb left the group and was replaced by John "Vic" Willis. All three fought in World War II. In 1946, they reunited and played the *Grand Ole Opry*. They recorded as the Oklahoma Wranglers and worked as a backup band for Hank Williams. The group left the *Opry* in 1949 and toured with Eddy Arnold until 1957. The Oklahoma Wranglers also performed in the films *Feuding Rhythm* and *Hoe Down*. The group changed its name from the Oklahoma Wranglers to the Willis Brothers.

JEAN SHEPARD. Ollie Imogene "Jean" Shepard (1933–2016) was born in Pauls Valley, Oklahoma. Jean released 71 single records and 25 studio albums. She became a member of the *Grand Ole Opry* in 1955. (Courtesy of Noel Thibault.)

MOLLY BEE. Molly Jean Beachboard, also known as Molly Bee (1939–2009), was born in Oklahoma City, Oklahoma. During the 1950s, she was a cast member of Cliffie Stone's *Hometown Jamboree* and later appeared on *The Tennessee Ernie Ford Show.* (Courtesy of Marilyn Tuttle.)

Four

ROCKABILLY

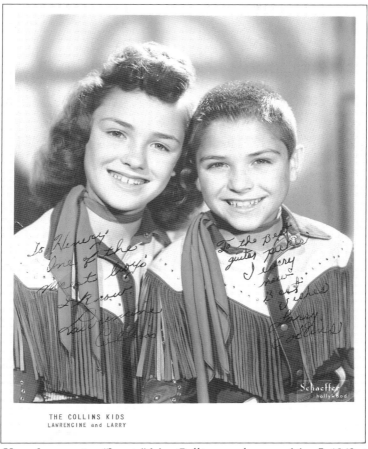

THE COLLINS KIDS
LAWRENCINE and LARRY

THE COLLINS KIDS. Lawrencine "Lorrie" May Collins was born on May 7, 1942, in Tahlequah, Oklahoma, and Lawrence "Larry" Albert Collins Jr. was born on October 4, 1944, in Pretty Water, Oklahoma. Their parents were Lawrence Albert and Hazel Juanita Robinson Collins. The father was a dairy farmer who was later employed as a crane operator in a steel mill. The mother was an amateur singer and mandolin player. At the age of eight, Lorrie won a talent contest hosted by Leon McAuliffe at the Cimarron Ballroom in Tulsa. McAuliffe urged her parents to move from Oklahoma to California, where Larry and Lorrie would have an opportunity to pursue a music career. The family moved to Long Beach, California, in 1953. In 1954, Larry and Lorrie became regular performers on *Town Hall Party*, a weekly program on Los Angeles television station KTTV. They were also featured on Tex Ritter's *Ranch Party*, a syndicated television program broadcast from 1957 to 1959. Larry played the guitar with incredible speed and dexterity. Lorrie was gorgeous, charming, a natural singer, and accompanied her brother on guitar.

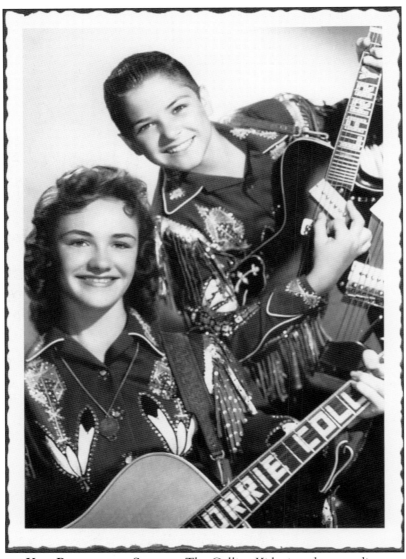

THE COLLINS KIDS PICKING AND SINGING. The Collins Kids signed a recording contract with Columbia Records in 1955. Larry and Lorrie were rockabilly sensations with several hit records through the early 1960s, including "Hot Rod," "Skip and Jump," and "Hoy." They were flashy and energetic performers who wore flashy Nudie suits. Ricky Nelson first saw Lorrie Collins on *Town Hall Party*. Ricky and Lorrie began dating. In 1958, Lorrie appeared in two episodes of *The Adventures of Ozzie and Harriet*. She appeared as Ricky's girlfriend and her identical twin sister. In a *Washington Post* interview, Larry recalled, "We grew up with Johnny Cash, Patsy Cline, Carl Perkins. Everybody that came to California when they first started did *Town Hall Party*. All those acts, Lorrie and I got to meet them, know them, travel with them, work with them. Lorrie and I had the luckiest childhoods of anyone that you can imagine." During the 1960s, the Collins Kids appeared regularly on the Canadian music show *Star Route*. They also appeared on *Shindig*, *The Steve Allen Show*, and *Grand Ole Opry*. In 1993, the Collins Kids reunited for a rockabilly revival concert in Hemsby-on-Thames in England. They continued to perform at rockabilly festivals until Lorrie's death. (Courtesy of Larry Collins.)

LORRIE COLLINS. Lorrie Collins married in 1959. She had the first of her two children in 1961. Lorrie wanted to be a stay-at-home mother. She semiretired from the music business except for occasional touring engagements and television performances. Larry Collins noted in her *New York Times* obituary that Lorrie died from "complications of a fall" on August 4, 2018, outside her home in Reno, Nevada. (Courtesy of Larry Collins.)

LARRY COLLINS AND RICO SUAVE. Larry Collins became a very successful songwriter. He was cowriter of "Delta Dawn" (nominated for a Grammy Award in 1973), "Tulsa Turnaround," and "You're the Reason God Made Oklahoma" (nominated for a Grammy in 1982). Larry also appeared in films, including *Smile* (1975), *Every Which Way But Loose* (1978), and *Every Which Way You Can* (1980). Larry continues to enjoy writing songs and occasionally performs at festivals and events. This recent photograph shows Larry and Rico Suave, his Havanese companion and closest friend. (Courtesy of Larry Collins.)

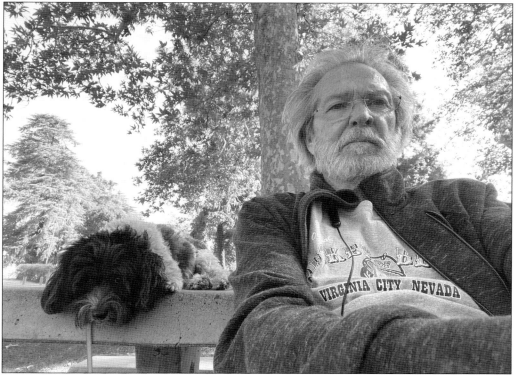

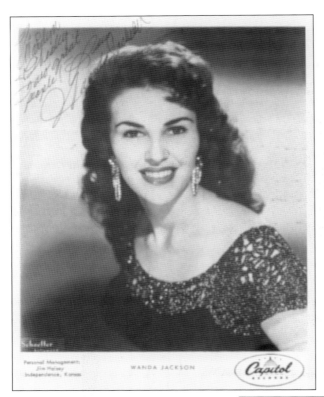

WANDA JACKSON. Wanda Lavonne Jackson was the only child of Tom and Nellie Jackson. She was born on October 20, 1937, in Maud, Oklahoma. During the early 1940s, her family moved to Los Angeles. At the age of six, Jackson learned to play guitar. During the mid-1940s, the family moved to Bakersfield. However, they returned to Oklahoma in 1946. At the age of 12, Jackson won a talent show contest on radio station KLPR that resulted in her own 30-minute radio program. (Courtesy of Marilyn Tuttle.)

HANK THOMPSON (LEFT), WANDA JACKSON, AND BILLY GRAY. In 1954, Hank Thompson heard Wanda Jackson singing on the show and asked her to perform with him at the Trianon Ballroom in Oklahoma City. She went on to appear with Thompson on local television and radio programs. Thompson tried to help her obtain a recording contract with Capitol Records. However, producer Ken Nelson replied, "Girls don't sell records." Thompson was eventually successful in helping Jackson sign a contract with Decca Records (1954). Her first release was "You Can't Have My Love," a duet with Billy Gray (Thompson's band leader). The song reached No. 8 on the country music charts. (Courtesy of Noel Thibault.)

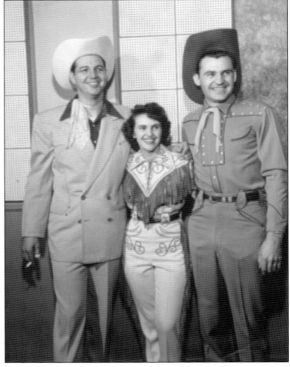

WANDA JACKSON IN A FRINGE DRESS. In 1956, Wanda Jackson signed a contract with Capitol Records. In 1958, she recorded "Fujiyama Mama." The song reached No. 1 on the charts and resulted in her tour of Japan in 1959. With Hank Thompson's help, Jackson began performing in Las Vegas nightclubs. She continued to release rockabilly hits, such as "Let's Have a Party." By the early 1960s, the British Invasion resulted in a decline of rock and roll. During that period, Jackson returned to her country roots. Between 1961 and 1973, Jackson released a series of country hits that included her composition "Right or Wrong." (Courtesy of Oklahoma Cultural Treasures.)

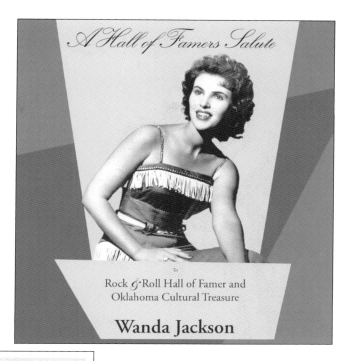

A Hall of Famers Salute

To

Rock & Roll Hall of Famer and Oklahoma Cultural Treasure

Wanda Jackson

WANDA JACKSON POSTER. From 1973 to 1978, Wanda Jackson recorded gospel records for the Work and Myrrh labels. During the 1980s, she was invited to Europe to perform at rockabilly and country music revivals. It was her first non-gospel tour since the early 1970s. Wanda Jackson, the "Queen of Rockabilly," retired from performing in 2019. She released a final album, *Encore*, in 2021. (Courtesy of the Tulsa Poster Project.)

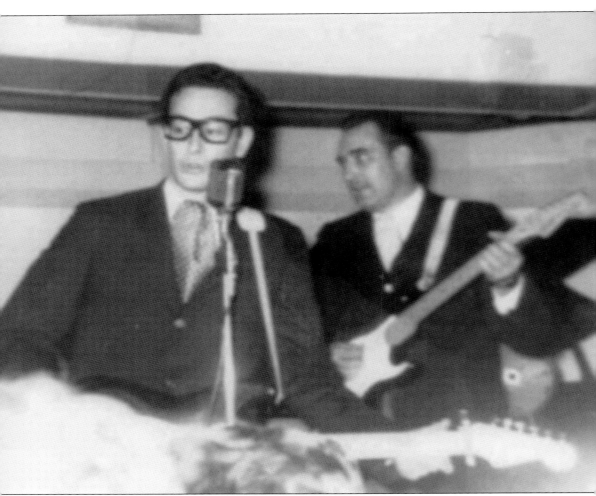

TOMMY ALLSUP (RIGHT) WITH BUDDY HOLLY. Tommy Allsup (1931–2017) was a guitar player for Buddy Holly. Allsup is perhaps best known for a February 3, 1959, coin toss to see whether Ritchie Valens or he would get a seat on the airplane with Buddy Holly. Allsup lost the toss and took a bus to the next stop on their tour. Another band member, Waylon Jennings, also chose to ride the bus. Jennings gave his seat to J.P. "the Big Bopper" Richardson. The plane crashed near Clear Lake, Iowa, and everyone aboard was killed on "the Day the Music Died." Holly jokingly told Jennings, "Well, I hope your ol' bus freezes up!" Jennings jokingly replied, "Well, I hope your ol' plane crashes!" This exchange haunted Jennings throughout his life. Allsup went on to play with Bob Wills, Roy Orbison, Merle Haggard, and Willie Nelson. He was a Grammy Award winner. (Courtesy of Benson Media.)

Five

FOLK AND BLUEGRASS

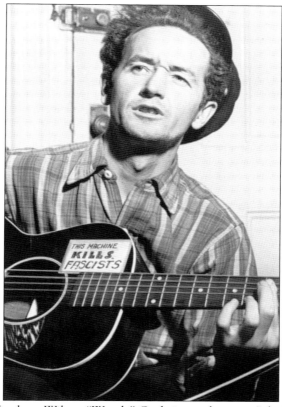

WOODY GUTHRIE. Woodrow Wilson "Woody" Guthrie was born on July 14, 1912, in Okemah, Oklahoma. When Woody was 14 years old, his mother, Nora, was admitted into the Oklahoma Hospital for the Insane with dementia and muscular degeneration. She was later diagnosed with Huntington's disease. The family moved to Pampa, Texas, where Woody's father hoped to repay debts resulting from unsuccessful real estate ventures. During his teenage years, Woody learned to play guitar and sing folk songs. In 1931, he married, but he left his wife and three children during the Dust Bowl era for California. In 1937, Woody and his cousin Jack Guthrie worked at radio station KFVD in Los Angeles. During this period, he met social activist Will Geer and novelist John Steinbeck. From May 1939 until January 1940, Woody wrote a column for *People's World*, a Communist newspaper. During the outbreak of World War II, there was a non-aggression pact between the Soviet Union and Germany. The owners of KFVD did not want to broadcast pro-Soviet sentiment and fired Guthrie. Woody died on October 3, 1967, from complications related to Huntington's disease, which also claimed his mother and his first two daughters. He is buried at Highland Cemetery in Okemah, Oklahoma. Guthrie was married three times and had eight children. (Courtesy of Oklahoma Tourism Commission.)

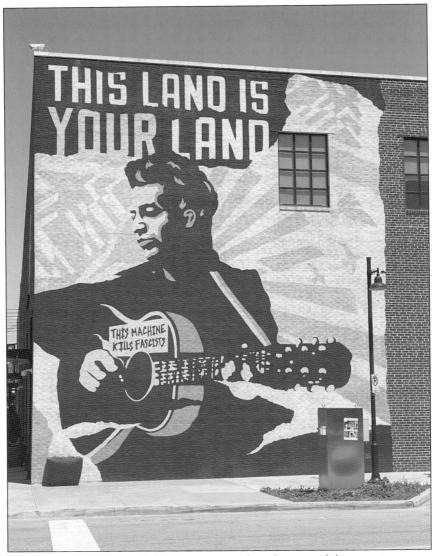

WOODY GUTHRIE CENTER. Woody Guthrie is remembered as one of the most important singers and songwriters of American folk music. His celebrated compositions include "Bound for Glory," "Hard Travelin'," "Oklahoma Hills," "Pastures of Plenty," "This Land Is Your Land," and an album of songs called *Dust Bowl Ballads*. Guthrie's compositions have become symbolic of the American folk song movement. They speak to the weak, downtrodden, and common people. His New York friends said that Woody would rather sleep on the floor to keep himself ready for traveling the road with working Americans. His lyrics and melodies are simple and straightforward. As Woody said, "Any fool can make something complicated. It takes a genius to make it simple." Woody's songs and recordings focused on themes of socialism and anti-fascism. In the early 1940s, Guthrie placed a sticker on his guitar that read, "This machine kills fascists." The label appeared on several of Woody's guitars, including the famous photograph of Guthrie playing his late-1930s Gibson L-00, a small-body guitar with a black finish. The Woody Guthrie Center is located in the Arts District of Tulsa. The artifacts and archives were purchased from the Woody Guthrie Foundation by the Tulsa-based George P. Kaiser Foundation. The museum opened in 2013.

50

HOYT AXTON. Hoyt Wayne Axton was born on March 25, 1938, to John Thomas and Mae Boren Axton in Duncan, Oklahoma. His father was a Navy officer who became a high school football coach. His mother was an English teacher who became a legendary songwriter. As a youth, Axton lived in Comanche, Oklahoma. His father's football coaching resulted in the family moving throughout southwest Oklahoma. In 1949, they moved to Jacksonville, Florida. Axton once said that "My pappy used to tell me 'It's not what happens to a man in his life that determines whether he's happy or not. It's how he reacts to what happens. He was quite the country philosopher. I grew up with all of those sayings. Both my parents were great influences on me. My mother wrote songs as a hobby, and I saw how much pleasure she got out of it so I started writing songs. And dad always sang. We'd be going down the highways in his old Plymouth, and he'd throw his head back and sing. He was a great singer." In 1955, Hoyt's mother gained lifetime fame when she cowrote "Heartbreak Hotel," the second song recorded by Elvis Presley at RCA Victor. In 1958, Axton received a football scholarship to Oklahoma State University but quit college to join the Navy. He remarked, "I was a terrible sailor, too. I couldn't even tie a bow knot." After being discharged from the Navy, Axton began writing songs and singing folk songs in San Francisco nightclubs and coffee houses. In 1962, he recorded his first album, *The Balladeer*, live at The Troubadour in West Hollywood, California. In 1963, his composition of "Greenback Dollar" became a hit record for the Kingston Trio. Axton appeared on television in *The Story of a Folksinger* (1963) and the *Hootenanny* television series (1964). However, his acting career began in 1965 with a minor role on *Bonanza*. Axton's song "The Pusher" became a No. 6 hit record for Steppenwolf (1968). The song was included on the soundtrack for *Easy Rider* (1969), starring Peter Fonda and Dennis Hopper. In 1971, his composition of "Joy to the World" became a No. 1 hit record for Three Dog Night. The group also recorded Axton's composition of "Never Been to Spain." During the late 1970s, Axton began to focus on his acting career. His credits included nearly 50 movies and television programs. He died on October 26, 1999, at his home in Victor, Montana. He had suffered a massive heart attack and another heart attack two weeks later while undergoing heart surgery. Axton had been married four times. He was survived by his wife Deborah and five adult children. (Courtesy of Jeremiah Records, Inc.)

BYRON BERLINE. Byron Douglas Berline was born on July 6, 1944, in Caldwell, Kansas, near the Oklahoma border. He was the youngest of five children raised by Lue and Elizabeth Jackson Berline. His father was a farmer who played banjo and fiddle at local barn dances. At the age of five, Bryon learned to play the fiddle. In 1963, Berline earned a football scholarship to the University of Oklahoma. A fractured hand ended his college football career. However, Byron maintained his athletic scholarship by throwing javelin for the track team. In 1965, the Dillards bluegrass band heard Byron fiddle with a college campus group. They invited him to play on *Pickin' & Fiddlin'*. When folklorist Ralph Rinzler heard the album, he asked Byron and his father to perform at the Newport Folk Festival. While at Newport, Byron met Bill Monroe, the father of bluegrass music. Monroe asked Byron to join his Blue Grass Boys. Bryon declined the opportunity, since he was still enrolled at the University of Oklahoma. However, he later played with Bill Monroe (in 1996 and 1997). After college, he was drafted into the Army and discharged from service in 1969. Byron and his wife, Bette, moved from Oklahoma to Los Angeles. He was soon performing with Dillard & Clark (1969 and 1970) and the Dillard Expedition (1970 and 1971). He also recorded with Bob Dylan, Elton John, Rod Stewart, John Denver, and many other music legends. Guitarist Dan Crary, banjo player John Hickman, and Berline formed Sundance in 1975, later changing the name to Berline, Crary & Hickman. He also played with the LA Fiddle Band (1978–1993) and California (1990–1996). Berline performed music for the television series *Northern Exposure* as well as the movies *Pat Garrett and Billy the Kid* (1973), *Back to the Future III* (1990), and *Basic Instinct* (1992). Byron also appeared as a musician in *The Rose* (1979) and was part of a string quartet in an episode of *Star Trek: The Next Generation*. In 1995, Bryon and his wife left Los Angeles and moved to Guthrie, Oklahoma, where he opened the Double Stop Fiddle Shop. Its name refers to the fiddle technique of playing two strings at the same time. In 1997, he formed the Byron Berline Band and helped organize the Oklahoma International Bluegrass Festival. In 2019, his store burned to the ground, consuming a large inventory of antique instruments. Several months later, he opened another shop on the same street. On July 10, 2021, he died at an Oklahoma City rehabilitation facility after a series of strokes. He was 77. He was survived by his wife, a daughter, and four grandchildren. (Courtesy of OK Roots Music.)

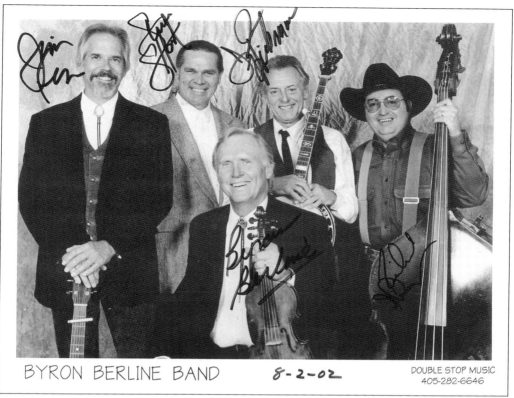

BYRON BERLINE BAND 8-2-02

DOUBLE STOP MUSIC
405-282-6646

BYRON BERLINE BAND. In 1995, Bryon and Bette Berline left Los Angeles and moved to Guthrie, Oklahoma. He opened the Double Stop Fiddle Shop. In 1997, he formed the Byron Berline Band and helped organize the Oklahoma International Bluegrass Festival. In 2019, the Double Stop Fiddle Shop burned to the ground. The fire consumed a large inventory of antique instruments. Several months later, he opened another shop on the same street.

BYRON BERLINE (LEFT) AND KARL ANDERSON. Berline and Anderson are pictured at the Huck Finn Jubilee in Victorville, California. During his years in Los Angeles, Berline performed music for the television series *Northern Exposure* as well as films that included *Pat Garrett and Billy the Kid* (1973), *Back to the Future III* (1990), and *Basic Instinct* (1992). Byron also appeared as a musician in the Bette Midler film *The Rose* (1979) and as part of a string quartet in an episode of *Star Trek: The Next Generation*. On July 10, 2021, Byron died at an Oklahoma City rehabilitation facility after a series of strokes. He was 77 years of age. He was survived by his wife, a daughter, and four grandchildren.

MASON WILLIAMS. Mason Douglas Williams was born in 1938 in Texas but moved to Oklahoma at the age of eight. He took music classes at Oklahoma City University. In 1968, Williams won three Grammy Awards for his composition and instrumental recording of "Classical Gas." (Courtesy of Acoustic Music.)

MID-1960s COUNTRY

SHEB WOOLEY. Shelby Fredrick "Sheb" Wooley was the son of William and Ora Wooley. He was born on April 10, 1921, in Erick, Oklahoma. Sheb lived on the family farm and learned to ride horses at an early age. As a teenager, he competed on the local rodeo circuit. Sheb also had an interest in music. At 15, he formed the Plainview Melody Boys. They performed on radio station KASA in Elk City. In 1940, Wooley married Melva Miller, a cousin of Roger Miller. Sheb and Roger became close friends, and they spent nights listening to Bob Wills and the Light Crust Doughboys. He taught Roger to play guitar and bought him his first fiddle. During World War II, Sheb worked in a munitions plant, as rodeo injuries had kept him from serving in the military. In 1945, Sheb signed a contract with the Bullett label. He made the first postwar 45-rpm recording at WSM studios in Nashville. The two sides of the record included "I Can't Live Without You" and "Oklahoma Honky Tonk Heart." (Courtesy of Linda Dotson-Wooley.)

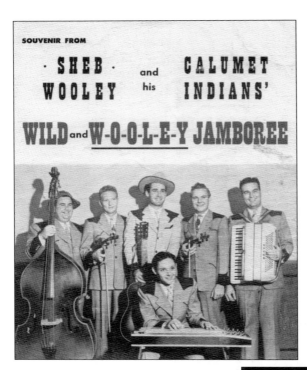

SOUVENIR FROM
· SHEB · and CALUMET
WOOLEY his INDIANS'
WILD and W-O-O-L-E-Y JAMBOREE

SHEB WOOLEY AND HIS CALUMET INDIANS. In 1946, Sheb Wooley moved to Fort Worth, Texas. During the next four years, he performed on radio with his Calumet Indians band. In 1950, Sheb, his second wife, and her infant son moved to Hollywood with hopes of working as an actor and singer in the film and television industry. Wooley performed in more than a hundred movies and hundreds of television shows. His movie credits include *Rocky Mountain* with Errol Flynn (1950), *High Noon* with Gary Cooper (1952), and *Hoosiers* (1986). (Courtesy of Linda Dotson-Wooley.)

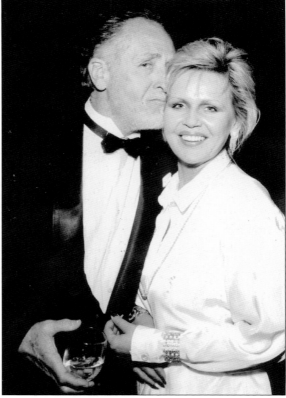

SHEB WOOLEY AND LINDA DOTSON-WOOLEY. In *Giant* (1956), Sheb Wooley taught James Dean how to ride a horse and talk like a Texan. He also performed with Clint Eastwood in the television series *Rawhide* (1959–1966). Sheb was also known as the originator of the "Wilhelm Scream." This sound bite originally came from the movie *Distant Drums* and as a voiceover in *Charge at Feather River*. The Wilhelm Scream has been used in more than 400 films and TV series, including *Raiders of the Lost Ark*, *Toy Story*, and each of the *Star Wars* films. (Courtesy of Linda Dotson-Wooley.)

"THE PURPLE PEOPLE EATER" SHEET MUSIC. In 1950, Sheb Wooley was hired as a songwriter for Hill & Range Music. This led to a contract with MGM Records that lasted 29 years. In 1958, he wrote and recorded "The Purple People Eater." The song was No. 1 on the US charts for six weeks and sold more than three million copies. By 2001, the record had sold more than 100 million copies. Sheb died from leukemia on September 16, 2003, in Nashville, Tennessee.

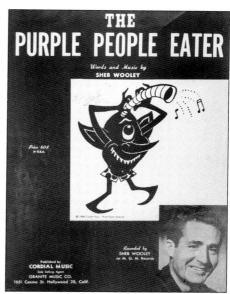

CONWAY TWITTY. Harold Lloyd Jenkins, also known as Conway Twitty, was born on September 1, 1933, in Friars Point, Mississippi. Jenkins was given a Sears Roebuck guitar at the age of four. His grandfather taught Jenkins to play guitar. At the age of 10, he formed his first band, the Phillips County Ramblers. At the age of 12, he performed on radio station KFFA in Helena, Arkansas. Jenkins was a talented baseball player. After graduating from high school, he was drafted by the Philadelphia Phillies. However, his professional baseball career ended before it started—he was drafted into the Army. While stationed in Japan, Jenkins formed an Army band called the Cimmarons. He entertained at local military bases and appeared on Armed Forces Radio. He also played on an Army baseball team. (Courtesy of Joni Twitty.)

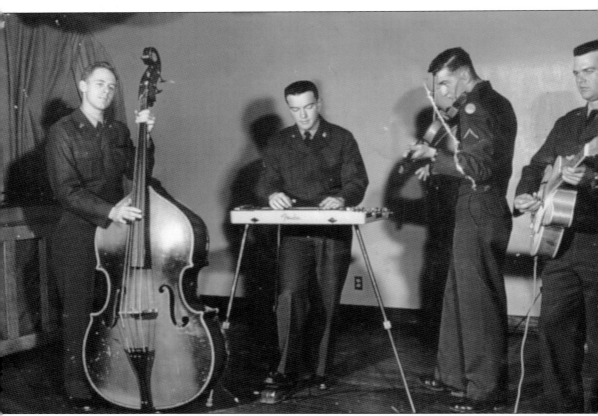

CONWAY TWITTY AND THE CIMMARONS. After discharge from service, Harold Lloyd Jenkins became fascinated by Elvis Presley. This inspired him to write songs and travel to Sun Records in Memphis. Although Jenkins recorded at Sun Studios, he sounded too much like Elvis, and his recordings were never released. However, another Sun Records artist, Roy Orbison, recorded and released Jenkins's song "Rockhouse." Jenkins then signed with Mercury as a rockabilly performer. He was asked to change his name, and in 1958, he combined the names of Conway, Arkansas, and Twitty, Texas, to create his stage name. Next, he signed a recording contract with MGM. Conway composed and recorded his first million-record hit "It's Only Make Believe" (1958). His success was followed by a string of hits into the early 1960s. He became a teen idol and appeared in teen movies, including *Platinum High School* and *College Confidential*. Conrad Birdie, a character in the Broadway musical *Bye Bye Birdie*, was a parody of Twitty. Conway recorded his first country top-10 hit "The Image of Me" in 1968. This was followed by a record number of 55 No. 1 country hits on *Billboard* magazine and more than 50 million records sold. Twitty wrote 19 of his No. 1 hit records. This achievement was unsurpassed until George Strait in 2006. Conway also received several CMA awards for duets with Loretta Lynn. From 1963 to 1972, Twitty lived in Oklahoma City. The family resided in a modest three-bedroom home located at 7000 South Villa Avenue. In 1964, he performed at the opening of the Diamond Ballroom in Oklahoma City. (Courtesy of familyphile.com.)

TWITTY BURGER MENU. In 1968, Conway opened a franchise restaurant chain known as Twitty Burger. His investors included Gov. J. Howard Edmondson and Merle Haggard. The first restaurant was at 7200 South Western Avenue in Oklahoma City. The grand opening was attended by Nashville celebrities such as Porter Wagoner, Dolly Parton, and Don Gibson. As a result of bad management, Twitty Burger went out of business in 1971. Twitty's performances were as dramatic as a religious revival and were attended by devoted female followers. Jerry Clower called him the "High Priest of Country Music." Conway did not speak on stage, allow interviews, attend music industry events, make television appearances, or perform encores (except "Hello Darlin' " when it became a monster hit). (Both, courtesy of Joni Twitty.)

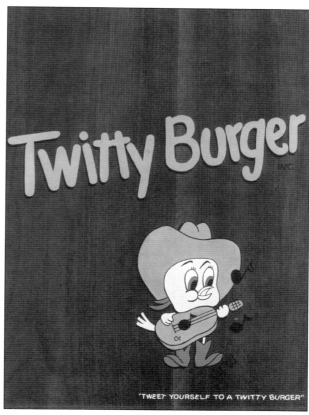

"TWEET YOURSELF TO A TWITTY BURGER"

TWITTY'S BURGERS

TWITTY BURGER 1.35

a meal in itself consisting of: 1/4 lb. USDA choice ground sirloin, bacon strips, crisp & juicy pineapple ring fried in our special batter on a "birdseed" bun*. . .served with fresh french fries.

MIDDI TWITTY BURGER 1.10

a slightly smaller version of the above. . .just right for the ladies.

ITTY BITTY TWITTY BURGER50

special burger for the kids. . .served on plain bun.

A slice of cheese melted on any of the above10

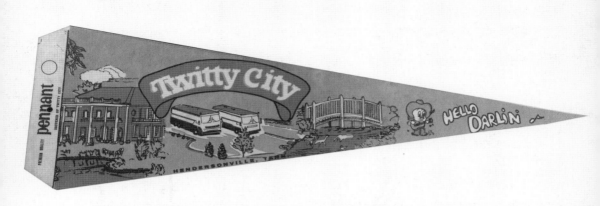

TWITTY CITY PENNANT. In 1981, he opened his $3-million Twitty City complex in Nashville and inaugurated the annual Country Explosion concerts to kick off Fan Fair. He became co-owner of the Nashville Sounds, a minor-league baseball team, and the United Talent booking agency. On June 4, 1993, Conway was returning home to Nashville from performing in Branson, Missouri, when he suddenly became ill on his bus and was transported to a Springfield hospital. He died on June 5 while undergoing surgery for an abdominal aortic aneurysm. Conway's four children (by prior marriages) and his widow (who was the same age as the oldest Twitty child) became involved in a lengthy and bitter dispute over his last will and testament, which left everything to the children. The decision, which was upheld by the state supreme court, split Twitty's assets between his four children and widow, even though his wife was not named in the unsigned will. Tennessee law guaranteed that his widow received one-third of Twitty's estate, which was estimated in excess of $12 million. The dramatic events that unfolded became an episode of *The Will: Family Secrets Revealed* (2011).

ROGER MILLER. Roger Dean Miller was born on January 2, 1936, in Fort Worth, Texas. In 1937, Roger's father, Jean Miller, died of spinal meningitis. His mother, Laudene Holt Miller, was unable to provide for the family. She gave her three boys to different uncles on the father's side. One boy went to Arkansas, another to California, and Roger went to live with Elmer and Armelia Miller on a small farm near Erick, Oklahoma. Roger had a wonderful sense of humor, saying at one of his concerts, "I was raised on a small truck farm in Erick, Oklahoma. We raised little GMC pickups." Roger's youth was spent picking cotton and working the land. However, Miller was a dreamer and did not enjoy farm work. Roger's uncle and friend Sheb Wooley once said "It's really a good thing that he made it in the music business 'cause he would have starved to death as a farmer." Sheb and Roger often listened to the *Grand Ole Opry* and *Light Crust Doughboys* on the radio. He taught Miller chords on the guitar and bought him a fiddle. At 17, Roger stole a guitar that he needed to write songs. However, Roger turned himself over to authorities the next day. He was given the choice of jail or joining the Army. Miller chose the military option and often said, "My education was Korea, Clash of '52." While in the Army, Roger played fiddle with the Circle A Wranglers, a band organized by Faron Young. He later met the brother of Jethro Burns, who arranged for Roger to audition with RCA in Nashville. When Miller auditioned with Chet Atkins, he was told to come back later when he had more experience. Roger began working at the Andrew Jackson Hotel in Nashville. He was known as "The Singing Bellhop." Miller would sing for anyone up and down the elevator. There he met George Jones and Don Pierce, an executive for Mercury Records. Roger was signed to a contract that resulted in three unsuccessful records. He began touring as a fiddle player with Minnie Pearl and drummer for Faron Young. After he married and became a father, Roger moved to Amarillo, Texas, where he worked briefly as a firefighter. There Miller met Ray Price, who asked him to join the Cherokee Cowboys. During the late 1950s, Roger returned to Nashville to become a successful songwriter. He wrote hits such as "Invitation to the Blues" (a No.3 hit for Rex Allen), "Half a Mind" (a No. 8 hit for Ernest Tubb), and "Billy Bayou" (a No.1 hit for Jim Reeves). In 1964, Roger signed a contract with Smash Records. He soon became a household name with records such as "Dang Me" and "Chug-a-Lug." Other hits included "Do-Wacka-Do," "King of the Road," and "England Swings." In two years, Roger won 11 Grammy Awards. In 1966, NBC premiered *The Roger Miller Show*, a TV variety show. In 1985, he wrote *Big River*, a Broadway play that won seven Tony Awards.

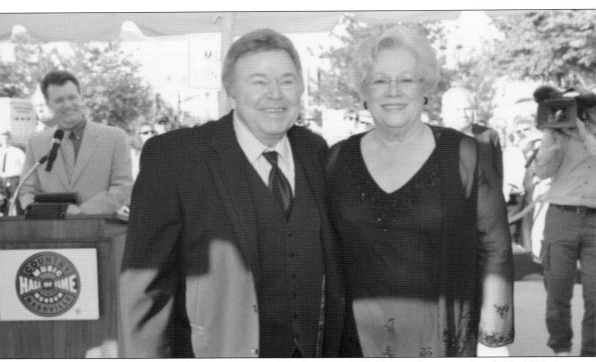

ROY CLARK AND HIS WIFE, BARBARA. Roy Linwood Clark was born on April 15, 1933, in Meherrin, Virginia. Clark's father, tobacco farmer Hester Linwood Clark, played banjo, fiddle, and guitar. His mother, Lillian Oliver Clark, played piano. During the Great Depression, the family moved to New York City, where his father obtained work. When he was 11, the family movd to Washington, DC, where his father worked at the Washington Navy Yard. Roy played his first guitar (a cigar box with a ukulele neck) in the elementary school band. At the age of 14, Roy's father taught him to play guitar. The boy soon learned to play banjo and mandolin; Roy reminisced that "Guitar was my real love, though." He said of the banjo, "When I started playing, you didn't have many choices to follow, and Earl Scruggs was both of them." Roy won the National Banjo Championship in 1947 and 1948. At 16, Clark made his first television appearance on WTTG in Washington, DC. At 17, he made his debut on the *Grand Ole Opry*. At 18, Clark was offered a tryout with the St. Louis Browns baseball team. At 19, he won 15 straight light heavyweight boxing matches. At 23, Roy obtained his pilot's license and purchased his first airplane. Flying became a lifetime passion. Clark's innate shyness was offset by his sense of humor. His quick wit helped him overcome his timid nature and was a hallmark of his stage presentation. His hit records include "Yesterday, When I Was Young" and "Thank God and Greyhound." Roy was best known as the cohost with Buck Owens on *Hee Haw*. The weekly program claimed 30 million viewers and became one of the longest-running syndicated shows in television history (from 1969 to 1997). Roy and Barbara Joyce Rupard were married in 1957 and had four children. They moved to Tulsa in 1974; his entertainment manager, Jim Halsey, convinced Roy that the move would allow easy access to both coasts for performances and the opportunity to spend more time at home. In 1978, an elementary school in the Union School District was named in his honor. Roy purchased the Tulsa Drillers, a Double-A baseball affiliate of the Los Angeles Dodgers. Roy also sang "Yesterday, When I Was Young" at the funeral for his friend Mickey Mantle in Commerce, Oklahoma. Roy later said, "I like [Tulsa] . . . I came here and was more accepted than I was in my own hometown. I'm glad I adopted Oklahoma and Oklahoma adopted me." Clark died on November 15, 2018, of complications from pneumonia at his home in Tulsa. (Courtesy of Jim Halsey, Inc.)

ROY CLARK. In 1978, an elementary school in the Union School District was named in Roy Clark's honor. Roy purchased the Tulsa Drillers, a Double-A baseball affiliate of the Los Angeles Dodgers. Roy later said, "I like [Tulsa]. . . . I came here and was more accepted than I was in my own hometown. I'm glad I adopted Oklahoma and Oklahoma adopted me." Roy and Barbara Joyce Rupard were married in 1957 and had four children. Roy died on November 15, 2018, of complications from pneumonia at his home in Tulsa. (Courtesy of Jim Halsey.)

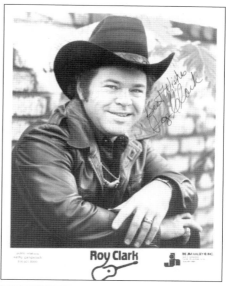

Roy Clark

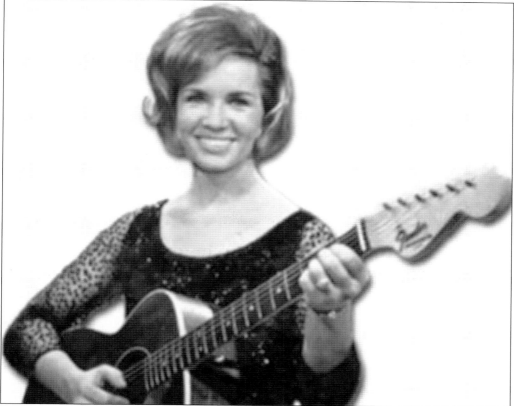

NORMA JEAN BEASLEY. Norma Jean Beasley was born in 1938 near Wellston, Oklahoma. Her parents were farmers who moved to Oklahoma City when Norma Jean was a young girl. She gained prominence as "Pretty Miss Norma Jean" on *The Porter Wagoner Show* from 1961 to 1967. (Courtesy of Bob "Boppin Bob" Jones.)

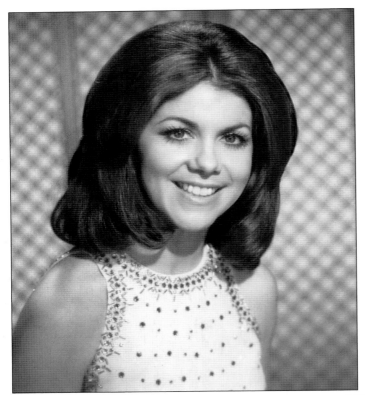

JODY MILLER. Myrna Joy "Jody" Miller (1944–2022) was born in Arizona but was raised in Blanchard, Oklahoma. Miller gained prominence with her recording of "Queen of the House," the answer song to Roger Miller's "King of the Road." The record was No. 12 on the *Billboard* Hot 100 and No. 5 on the country singles chart and won her the Grammy Award for Best Female Country Vocal Performance in 1966. During the 1980s, Jody released several gospel albums. (Courtesy of the *Oklahoman*.)

BONNIE OWENS. Bonnie Campbell (1929–2006) was born in Blanchard, Oklahoma. At 15, she met Buck Owens in Arizona, and they married in 1948. They moved to Bakersfield, California, had a son (Buddy Alan), and divorced in 1953. She was married to Merle Haggard from 1965 to 1978. Bonnie recorded as a solo artist and sang backup for Haggard's band the Strangers from the mid-1960s to the late 1990s. (Courtesy of MetroLyrics.)

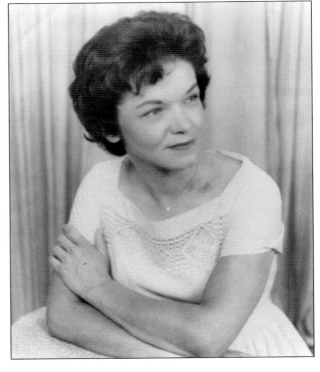

Seven

TULSA SOUND

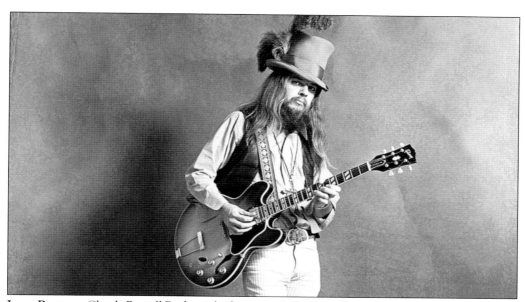

LEON RUSSELL. Claude Russell Bridges, also known as Leon Russell, was born in Lawton, Oklahoma, on April 2, 1942. He was the son of John Griffith and Hester Evel Whaley Fullbright. At the age of four, Russell began playing classical piano; he learned to play trumpet in the fifth grade and was a member of the Maysville High School band. By the time Russell attended Will Rogers High School in Tulsa, he was performing at local nightclubs, including Griff's Supper Club, the House of Blue Lights, the Sheridan Club, and the Playmor Ballroom. Russell formed the Starlighters, a group that included J.J. Cale, Chuck Blackwell, Leo Feathers, and Johnny Williams. While Leon was studying for entrance exams to attend Tulsa University, the Starlighters were invited to tour with Jerry Lee Lewis. Russell decided that music was his passion, so he abandoned college, went on tour with Lewis, and began a successful career. Russell once stated that his early years in Tulsa were some of the most influential in his career. He recalled, "Oklahoma was a dry state back when we started. Since there wasn't supposed to be any liquor, there weren't any liquor laws, so there was a lot of clubs where people would go and drink for 24 hours a day. The police didn't pay any attention. It was a wide-open town. When people don't get caught up in that political morality, it creates a hotbed of musical experience." During the late 1950s and early 1960s, Russell helped originate the "Tulsa Sound," a laid-back combination of country, blues, rock and roll, rockabilly, and swamp rock. In 1959, Leon moved from Oklahoma to California, where he played in nightclubs. He also became a part of the "Wrecking Crew," a group of session musicians that played on hit records throughout the 1960s. As a pianist, he played on albums by the Beach Boys, Dick Dale, Jan and Dean, the Rolling Stones, Elton John, George Harrison, Ringo Starr, Eric Clapton, Willie Nelson, and Bob Dylan. In 1970, Russell recorded his first album, which included Eric Clapton, Ringo Starr, and George Harrison. In 1971, Leon won a Grammy Award for his performance at the Concert for Bangladesh, along with Harrison, Dylan, and Clapton. (Courtesy of the Leon Russell Estate.)

LEON RUSSELL POSTER. Elton John said that Leon Russell was a "mentor" and an "inspiration." In 2010, they recorded their album *The Union* and earned a Grammy nomination. Russell eventually left Los Angeles and returned to Tulsa, where he established his famous Church Studio and Tulsa-based label Shelter Records. During the 1970s, Church Studio became one of the most legendary places to record music. Bob Dylan, Eric Clapton, the GAP Band, and Tom Petty were among the artists who recorded at his studio. Russell's wild hair, raspy voice, and fast pace (he once recorded 26 songs in a day and a half), earned his nickname "Master of Space and Time." During his career, Leon recorded an estimated 31 albums and 430 songs. His recordings earned six gold records, and he received seven Grammy nominations that resulted in two Grammy Awards. His 50-year career spanned numerous genres, including rock and roll, country, gospel, bluegrass, rhythm and blues, the Tulsa Sound, and others. Russell died on November 13, 2016, from a heart attack while recovering from open-heart surgery. He was twice married and had six children. (Both, courtesy of the Leon Russell Estate.)

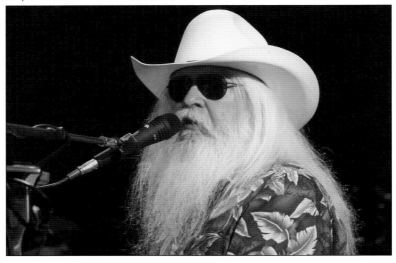

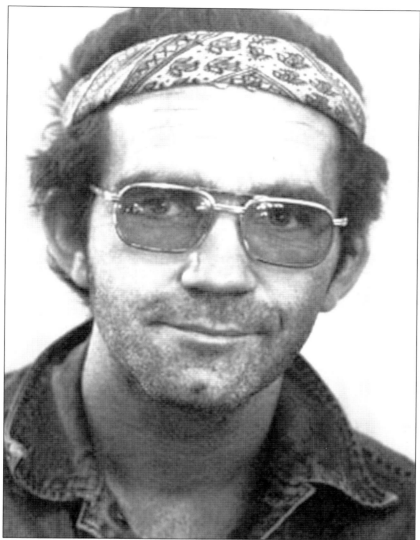

J.J. CALE. John Weldon "J.J." Cale was born on December 5, 1938, in Oklahoma City. He was raised in Tulsa and graduated from Tulsa Central High School. Cale loved music and performed on a friend's guitar while hoping to earn enough money to purchase an instrument of his own. His early influences included Elvis Presley, Chuck Berry, Buddy Holly, Chet Atkins, Little Richard, and Fats Domino. Cale recalled that he tried playing like his guitar idols, but said, "I missed it and came up with my own kind of thing." As a teenager in Tulsa during the 1950s, Cale formed a group called Johnny Cale and the Valentines. He played alongside friends, including Leon Russell, for "ten dollars a night and all the beer you could drink." In 1959, Cale moved to Nashville to become a touring company member of the *Grand Ole Opry*. He played whatever type of music the venue required, including country, Western swing, or rock and roll. Cale simply loved to perform. In 1964, Cale moved to Los Angeles and worked as a studio engineer with Leon Russell. In 1965, Cale recorded "After Midnight" for Liberty Records. Cale seemed to be going nowhere in California and was on the verge of abandoning his music career. In 1968, Cale returned to Oklahoma to play the Tulsa club circuit. In 1969, he signed a recording contract with Leon Russell's Shelter Records. (Courtesy of All About Blues Music.)

J.J. Cale Poster. In the meantime, Cale's music industry friends thought he had real talent. His demo of "After Midnight" was given to Eric Clapton, and in 1970, Clapton recorded the song. The release became Clapton's first solo hit. Cale first heard Clapton singing "After Midnight" while listening to the radio in his car. He recalled years later in an NPR interview thinking, "Oh, boy, I'm a songwriter now. I'm not an engineer or an elevator operator." In 1971, Cale released his first album, *Naturally*, which included a newly recorded version of "After Midnight"; he changed the song's tempo to differentiate it from Clapton's version. In 1972, Cale's recording of "Crazy Mama" reached No. 22 on the Billboard Hot 100. Some of his most famous songs were recorded by Waylon Jennings ("Louisiana Women"), Carlos Santana ("Sensitive Kind"), Randy Crawford ("Cajun Moon"), Lynyrd Skynyrd ("Call Me the Breeze"), and Eric Clapton ("After Midnight" and "Cocaine"). In 2006, Cale and Clapton recorded *The Road to Escondido*, which won a Grammy Award for Best Contemporary Blues Album. J.J. Cale is best remembered for his role in helping to originate and promote the Tulsa Sound. Despite his success as a singer, songwriter, and guitarist, Cale was extremely private. He rarely performed in public, did not include his photograph on album covers, and avoided publicity. In a 1990 newspaper interview, he said, "I'm a background person. I'm not a household name. People have heard my music, but all my famous songs were made famous by somebody else. . . . But that was my goal." Neil Young once said, "Of all the players I ever heard, it's gotta be Hendrix and J.J. Cale who are the best electric guitar players . . . musically, he's actually more than my peer, because he's got that thing. I don't know what it is." Eric Clapton described Cale as "one of the most important artists in the history of rock." In 1989, Cale moved to rural Valley Center, California, to avoid the public. He died of a heart attack at Scripps Hospital in La Jolla, California, on July 26, 2013. He was 74 years of age and was survived by his wife, Christine. (Courtesy of posterchild.com.)

Eight

SONGWRITERS

ALBERT BRUMLEY. Albert Edward Brumley Sr. was born on October 29, 1905, near Spiro, Oklahoma, to William Sherman and Sarah Isabelle Williams Brumley, sharecroppers who later purchased a cotton farm near Rock Island, Oklahoma. His parents were devout Campbellite Protestants, a conservative branch of the Restoration Movement. Music was an important part of Albert's life. His father was a fiddler, and his mother enjoyed singing parlor songs. He completed 10th grade in Rock Island and attended a shape-note singing school that inspired his passion for gospel music. In 1926, Albert walked 28 miles to Hartford, Arkansas, where he dreamed of attending the Hartford Music Institute and composing gospel music with E.M. Bartlett. In 1927, he graduated and published his first song for Hartford ("I Can Hear Them Singing Over There"). Albert became a staff songwriter, sang with the Hartford Quartet, and was a singing-school teacher in the tri-state area. In 1929, Albert returned to the Rock Island family farm, where they planted and picked cotton. As Albert worked, he recalled "humming the old ballad that went like this; 'if I had the wings of an angel, over these prison walls I would fly' and suddenly it dawned on me that I could use this plot for a gospel-type song." This event was his inspiration for composing "I'll Fly Away." (Courtesy of Betsy Brumley.)

ALBERT BRUMLEY (RIGHT) AND E.M. BARTLETT. In 1931, Albert Brumley married Goldie Edith Schell. They moved to Powell, Missouri, where they lived throughout their life. The couple raised six children. In 1937, Albert published his first songbook, *Albert E. Brumley's Book of Radio Favorites.* During the early 1940s, Albert worked as a staff songwriter for the Stamps-Baxter Music Company in Dallas, Texas. (Courtesy of Betsy Brumley.)

ALBERT E. BRUMLEY'S BOOK OF RADIO FAVORITES. In 1943, Albert Brumley formed his own publishing company, Albert E. Brumley and Sons. E.M. Bartlett died in 1941. Brumley eventually purchased the Hartford Music Company in 1948 and acquired the copyrights to many of his most popular songs. He formed a cooperative of music publishers with an agreement that allowed them to use each other's songs; however, they would sell their own books and keep the money from what they sold rather than sending royalties back and forth to each other. Brumley and Sons printed more than 40 million songbooks for the *Grand Ole Opry, Ozark Jubilee,* Bob Wills, and other prominent barn dances and popular entertainers of the day.

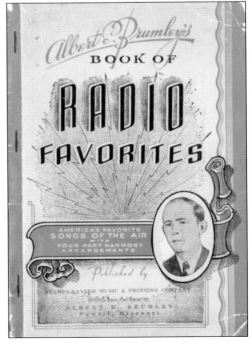

Brumley Sons Making Songbooks. September 13, 1975, was declared by Oklahoma governor David Boren as Albert E. Brumley Gospel Music Day. In 1976, "I'll Fly Away" was named "Most Recorded Gospel Song in History" by SESAC (Society of European Stage Authors and Composers). His other gospel classics include "Turn Your Radio On," "I Will Meet You in the Morning," "Jesus Hold My Hand," "Camping in Canaan's Land," and "This World Is Not My Home." He also wrote many secular hits, including "Rank Strangers," "Did You Ever Go Sailing," and "There's a Little Pine Log Cabin." It is estimated that Brumley composed between 600 and 800 songs during his career. Albert Brumley died on November 15, 1977, in Springfield, Missouri. He was survived by his wife, five sons, a daughter, and sixteen grandchildren. As Merle Haggard said on his *Land of Many Churches* album, "He was the Hank Williams of gospel music." In 1975, Albert and Goldie sold Albert E. Brumley & Sons to sons Robert and William. In 1986, Robert purchased his brother's 50 percent interest and became the sole owner of the Brumley music catalog, which included "I'll Fly Away." In 2008, four of the six Brumley siblings filed a lawsuit over the ownership the song. Albert had assigned the 1932 copyright to a company that subsequently became the property of Robert Brumley. In 1979, Albert's widow also executed an assignment in favor of Robert. During the term of a copyright, an author may use, assign, sell, or license the copyright. However, songwriters and their descendants may terminate the songwriter's assignment of a copyright to another party. The plaintiffs filed notice to terminate the assignment to Robert. During that time, the copyright was generating royalties of about $300,000 per year. In 2016, the US Court of Appeals for the Sixth Circuit affirmed the plaintiffs' right to terminate the assignment and rejected arguments that the song was a "work made for hire," which would not have been eligible for termination, and that Albert's widow had relinquished any termination rights. The court ruled that each of the six children would own an equal share in "I'll Fly Away." (Courtesy of Betsy Brumley.)

DALLAS FRAZIER. Dallas June Frazier (1939–2022) was born to William Floyd and Eva Marie Laughlin Frazier in Spiro, Oklahoma. His parents were itinerant farm laborers. In 1942, the family moved from Oklahoma as part of the Dust Bowl–era migration to the San Joaquin Valley near Bakersfield, California. Dallas said, "We were part of *The Grapes of Wrath*. We were the Okies who went out to California with mattresses tied to the tops of their Model A Fords. My folks were poor." The Frazier family lived in tents and boxcars in the California labor camps. He began picking cotton at the age of six. As a young boy, Frazier taught himself to play guitar and piano. His website biography states that "God would reveal to Dallas his unique gift of writing. A gift that enabled him to write songs by age eleven." In 1952, Dallas won a talent contest hosted by country music legend Ferlin Husky. Shortly thereafter, Frazier became part of Husky's road show. In 1953, Dallas signed a recording contract with Capitol Records and released his first single, "Space Command." (Courtesy of Tyler Mahan Coe.)

DALLAS FRAZIER WITH GUITAR. From 1954 to 1958, Dallas appeared on Cliffie Stone's *Hometown Jamboree*, a popular country music television program in Los Angeles. He also performed on Cousin Herb Henson's *The Trading Post*, a country music television show in Bakersfield. (Courtesy of Gerard "Rocky" Lambert.)

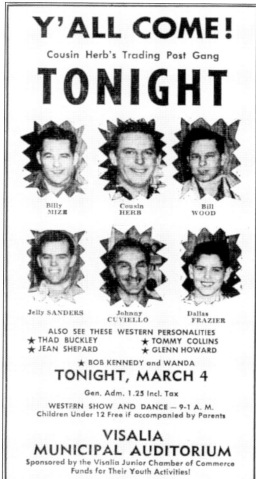

DALLAS FRAZIER WITH COUSIN HERB'S TRADING POST GANG. In 1957, Dallas Frazier wrote and recorded "Alley Oop." However, the song became a No. 1 hit record for the Hollywood Argyles. In 1963, Dallas moved to Nashville and became a songwriter for Ferlin Husky's publishing company. Then he worked as a staff songwriter for Acclaim Music, a publishing company owned by Jim Reeves. Frazier's real success came during the time he was employed by Ray Baker at Blue Crest Music. In 1967, Jack Greene released Frazier's "There Goes My Everything." The record was voted by the Country Music Association as Song of the Year. Frazier died on January 14, 2022, in Gallatin, Tennessee, following two strokes in August 2021. Dallas was married to Sharon Carpani Frazier for 63 years. They had two daughters. (Courtesy of *Billboard* magazine.)

MAE BOREN AXTON. Mae Boren Axton was born on September 14, 1914, to Mark L. and Nannie Boren in Bardwell, Texas. The family moved to Lawton, Oklahoma, when Mae was two years old. In 1927, the family relocated to a farm near Choctaw. Mae attended East Central State College and the University of Oklahoma. She received a bachelor's degree in journalism and obtained a teaching credential. During her college years, Mae married John T. Axton, a Navy officer who later became a high school football coach. She was the mother of folk singer and songwriter Hoyt Axton and attorney John Axton. In 1949, the family moved to Jacksonville, Florida, where her husband was stationed with the Navy. After moving to Florida, Axton began writing songs with local musicians Tommy Durden and Glen Reeves. In the meantime, Mae became a publicist for country music legend Hank Snow. Mae also worked as a local disc jockey who invited a young Elvis Presley to be interviewed on her radio program. She introduced Presley to Hank Snow's manager, "Colonel" Tom Parker. In 1955, Mae helped Elvis obtain a recording contract with RCA Victor Records. (Courtesy of the Oklahoma Historical Society.)

Mae Boren Axton and Elvis Presley. In less than 30 minutes, Axton and Durden composed "Heartbreak Hotel." Mae played a demo for Elvis at a convention in Nashville. After listening to the song, Elvis remarked, "Hot dog, Mae, play that again." The song became Presley's first No. 1 hit record on the Billboard charts and the biggest hit of 1956. Mae gave Elvis a songwriting credit that gave him a third of the royalties. Mae Axton is credited with writing more than 200 songs and helped develop the songwriting talents and careers of many country music artists. Known as the "Queen Mother of Nashville," she died on April 9, 1997, at her home in Hendersonville, Tennessee. Her cause of death was drowning in her hot tub after an apparent heart attack. (Courtesy of Elvis Australia.)

JIMMY WEBB. Jimmy Layne Webb was born on August 15, 1946, in Elk City, Oklahoma. His father, Robert Lee Webb, was a Baptist minister who presided over rural churches in Southwestern Oklahoma and West Texas. With his mother's encouragement, Jimmy learned piano and organ. By the age of 12, he was playing in his father's churches, accompanied by his father on guitar and mother on accordion. During his early teens, Jimmy began writing songs and bringing his creativity by improvising and arranging church hymns. His father did not permit anything other than country and gospel music on the radio. During the late 1950s, Jimmy was influenced by rock and roll. In 1961, he bought his first record, "Turn Around, Look at Me" by Glen Campbell. In 1963, the Webb family moved from Laverne, Oklahoma, to Colton, California. In 1965, Jimmy's mother died unexpectedly. His father decided that the family should return to Oklahoma. Against his father's wishes, Jimmy stayed in California and attended San Bernardino Valley College to study music and pursue a career as a songwriter. His father said, "This songwriting thing is going to break your heart." Before leaving California, Jimmy's father gave him his last $40. At the age of 18, Jimmy Webb was alone, driving an old Volkswagen and living at the Driftwood Motel in Colton. Within three years, Jimmy quit school, moved to Hollywood, and became the songwriter for Soul City Records. Jimmy began working with the Fifth Dimension and wrote their hit record "Up, Up and Away" (1967). This composition earned him a Grammy Award as writer for Song of the Year. Jimmy Webb composed hits such as "MacArthur Park" (1968 Grammy Award) and "The Highwayman" (No. 1 country hit in 1985). Glen Campbell recorded a string of hits written by Jimmy Webb, including "By the Time I Get to Phoenix" (1967 Grammy Award), "Wichita Lineman" (1967 Grammy Award), "Galveston," and "Where's the Playground Susie." In a November 2015 *Daily Record* article, Jimmy talked about meeting Glen Campbell. He said, "Mr. Campbell, I'm Jimmy Webb." Glen looked up and Webb and said, "When are you gonna get a haircut?" (Courtesy of Silvio Canto Jr.)

JIMMY WEBB WITH A BEATLES-STYLE HAIRCUT. Jimmy Webb's inspiration for "Wichita Lineman" came while driving through Washita County in Southwestern Oklahoma. Driving past what seemed to be an endless line of telephone poles, Webb finally came in view of a lineman on top of a distant pole, "a picture of loneliness." Webb "put himself atop that pole and put that phone in his hand" and wondered what the lineman was saying into the receiver, creating a modern-day musical masterpiece. Beginning in 1968, Webb recorded seven albums. Each of the projects received positive reviews. However, he never achieved success as a performer compared to his songwriter accomplishments. Webb returned to Oklahoma to perform for special events including the 2001 reopening of Oklahoma City's Civic Center Music Hall and the 2002 dedication of the Oklahoma State Capitol dome. He credits Oklahoma for his success, saying that "whatever created Jimmy Webb the songwriter, it was done in Oklahoma. The vernacular of hometown America is a language I speak. It's a language that makes for comfortable radio and for iconic touchstones. In Oklahoma, there's a gentle humanity that connects everyone. There's nothing on this earth more genuine than an Okie." (Courtesy of the *Houston Chronicle*.)

EDDIE MILLER. Edward "Eddie" Monroe Miller (1919–1977) was born in Camargo, Oklahoma. His most famous composition was "Release Me (and Let Me Love Again)." (Courtesy of Second Hand Songs Project.)

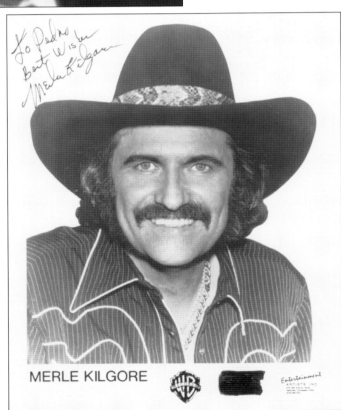

MERLE KILGORE. Wyatt Merle Kilgore (1934–2005) was born in Chickasha, Oklahoma. He was the cowriter of such hits as "Ring of Fire" and "Wolverton Mountain." He was also the personal manager for Hank Williams Jr. (Courtesy of www.last.fm.)

MERLE KILGORE

Nine

STEEL GUITAR PLAYERS

LEON McAULIFFE. William Leon McAuliffe was born on January 3, 1917, in Houston, Texas. He became known as the "World's Greatest Western Swing Steel Guitarist." McAuliffe began playing both Hawaiian and standard guitar at 14. In 1931, He began appearing on a local radio station with a group called the Waikiki Strummers. In 1933, McAuliffe quit school to join the Light Crust Doughboys. The group was based in Fort Worth, Texas, and featured a young fiddle player named Bob Wills. McAuliffe auditioned for the group by playing his composition "Steel Guitar Rag," a tune that he adapted from a combination of Sylvester Weaver's "Guitar Rag" and part of the Hawaiian song "On the Beach at Waikiki." McAuliffe worked to blend his resonator and Hawaiian guitar techniques into the sound of Western swing. The electric steel guitar became popular during the mid-1930s. The instrument was able to project a high volume of sound and sustain longer tones. The steel guitar suddenly became a lead instrument, and McAuliffe was ready to take the lead. In 1935, he became a member of Bob Wills and His Texas Playboys in Tulsa. In 1936, Wills said to McAuliffe, "I'm going to do something different on this. You hit a chord and I'm going to say something and then you start playing." So, McAuliffe recalled that he made a slide into an E chord, and Wills said, "Look out friends. Here's Leon. Take it away my boy, take it away!'" McAuliffe cowrote the instrumental version of "San Antonio Rose" and helped to popularize steel guitar in the United States. During the 1940s, McAuliffe appeared in a dozen movies. His first film, *Take Me Back to Oklahoma* (1940), featured Bob Wills and His Texas Playboys. In 1942, McAuliffe left the Texas Playboys to enlist in the Army and became a flight instructor. After discharge from service, McAuliffe returned to Tulsa. He formed his Western Swing Band. In 1949, their recording of Panhandle Rag reached No. 6 on the *Billboard* country music charts. Leon later purchased the Cimarron Ballroom (originally the Akdar Shrine Mosque) and changed the name of his group to the Cimarron Boys. (Courtesy of travelok.com.)

LEON MCAULIFFE COLUMBIA RECORDS AD. Throughout the 1950s and 1960s, Leon McAuliffe enjoyed tremendous success playing on KVOO and KRMG as well as performing throughout the United States. In 1954, he purchased radio station KAMO in Rogers, Arkansas. His television appearances included *Ozark Jubilee* (1960) and *The Jimmy Dean Show* (1965).

LEON MCAULIFFE POSTER. In 1971, Leon McAuliffe and Bob Wills recorded a reunion album with Merle Haggard and members of the Texas Playboys. When Wills died in 1975, McAuliffe became the leader of the Original Texas Playboys. The reorganized group continued to tour until 1980. (Courtesy of the Tulsa Poster Project.)

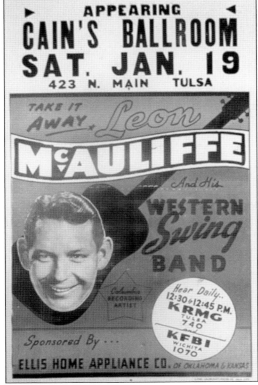

LEON MCAULIFFE LATER IN LIFE. During the 1980s, Leon McAuliffe, Eldon Shamblin, and Junior Brown taught music at Rogers State University for the Hank Thompson School of Country Music in Claremore, Oklahoma. The goal of the school was to preserve the legacy of traditional Western swing music. There, he formed a group called the New Cimarron Boys. McAuliffe died in Tulsa on August 20, 1988, at the age of 71 from kidney and liver failure related to a heart issue. He was survived by his wife, Ezell; a daughter; and two sons. (Courtesy of travelok.com.)

Noel Boggs. Noel Edwin Boggs was born in Oklahoma City on November 14, 1917, to a family of modest means. At eight years of age, Noel witnessed his father being shot to death over a water dispute on their farm. Around 1929, Noel's mother, Anna, purchased a Sears Roebuck guitar for his brother Richard, who was recovering from surgery. Their mother was unable to visit the hospital, so Noel was asked to be his brother's companion. Richard had no interest in playing guitar, but Noel entertained his brother by propping the guitar across his lap and matching notes from songs on the radio. As a youth, Boggs began playing steel guitar. His first instrument was a Rickenbacker lap steel, which was the first electrified string instrument of any type. By 1935, he was performing on three local radio stations while attending school. Shortly before graduation in 1937, Noel was invited to join Hank Penny's Radio Cowboys for a tour of the southeastern United States. During the late 1930s, Noel returned to Oklahoma City, where he hosted an early morning show and performed with the Jimmy Wakely Trio on radio station WKY. In 1941, he started his own band, and they performed at the Rainbow Room in Oklahoma City for three years. (Courtesy of Volker Houghton.)

Noel Boggs Performing at the Rainbow Room. In 1944, Noel Boggs replaced Leon McAuliffe as the steel guitar player for Bob Wills and His Texas Playboys. He left Bob Wills in 1945 and joined Spade Cooley's dance band. While performing with Cooley at the Santa Monica Ballroom, he met Leo Fender. Boggs and Fender became close friends. Boggs became the owner of Fender's first steel guitar. Billy Strange remembered, "Speedy [West], Noel Boggs, Jimmy Bryant, and I—the four of us would go out there [to the Fender factory] and just play around as much as we could and help them with design, and tell them the things that we wanted to see put on the instrument." Boggs left Spade Cooley in 1954 and formed his own quintet. He played around Southern California and Nevada until the late 1960s. During the early days of steel guitar, the instrument was limited to basic chords. The only way to add chords and voicings was to add additional guitar necks, each tuned differently. In 1949, Fender made a triple-neck steel for Boggs with a metal frame and legs. In 1953, Fender built a quadruple-neck model known as "Boggs' Quad." Eventually, the pedal steel guitar replaced multiple-neck steel guitars. However, Boggs continued to play his four-neck steel guitar. (Courtesy of *Billboard* magazine.)

the Rainbow Room

30th FLOOR

1st. National Bldg.

Oklahoma's

Most

Exclusive

Restaurant

DINING and DANCING NIGHTLY

• Music by •

NOEL BOGGS

and his Orchestra

Featuring Dorothy Osmon

TOPS in LOCATION ENTERTAINMENT FOOD

OPEN TO ALL

Service Starting 6:00 p. m. We close—Weekdays and Sundays—1:00 a. m., Saturday—2:00 a. m.

Reservations—3-2558

NOEL BOGGS TRIO AT HOLLYWOOD PLAZA HOTEL. Noel Boggs appeared on some 2,000 recordings. He played on several Bob Wills classics, such as "Roly Poly" and "Stay a Little Longer." Boggs died on August 31, 1974, from a stroke and heart attack. He was survived by his wife, Helen Mae, and three children. After Noel's death, his daughter Sandra spent 15 years searching for Boggs' Quad. The search led her to the owner of a defunct recording studio where Boggs had produced three albums. (Courtesy of Volker Houghton.)

NOEL BOGGS AND HIS FAMILY. Sandra Boggs was told that the guitar had been stored in a broom closet and that the janitor "might know more." She went on to say in a *Vintage Guitar* magazine article, "I located him [the janitor] via lots of phone calls, and he told me the guitar was under his bed, waiting to be claimed. So, I drove the 100 miles to his home in Chino. He told me that he'd put the guitar in that closet because Les was going to throw it out. He said, 'I loved your dad's music—and him!' He was a funny and genuine fellow, and said he couldn't stand to see the guitar thrown in the dumpster. He had a hunch that eventually, someone from the family would come to get it, and he told me, 'I've been waiting for you for a long time!' I offered him some money, but he refused. He helped me load it into my car. I told him how much it meant to me and my family, and I went home with a piece of my father." (Courtesy of Volker Houghton.)

SPEEDY WEST. Wesley Webb "Speedy" West was born on January 25, 1924, in Springfield, Missouri. He was the son of Finley G. and Sue West. His father played guitar and sang gospel songs. At the age of nine, Wesley became interested in music. His father bought him a $12 Hawaiian guitar, and Wesley spent his spare time learning to play the instrument. When Wesley expressed interest in a more expensive guitar, his father sold his own guitar to purchase him a National steel-bodied resonator model for $125. In 1946, a *Grand Ole Opry* tent show came to Springfield. The show featured Eddy Arnold's steel guitar player, "Little Roy" Wiggins. Wesley was inspired by Wiggins and began thinking about a music career. Later that year, Wesley was playing at a KWTO jam session in Springfield. A local country music personality introduced Wesley to the audience as "Speedy" West. On June 13, 1946, Speedy, along with his wife, Opal, and son, moved to Southern California. Despite several breakdowns, they arrived in Los Angeles three days later. West began playing with the Missouri Wranglers at the VFW Hall in Southgate. His talent was starting to be noticed by local artists. He purchased an amp from Leo Fender and felt he needed a more up-to-date steel guitar to replace his homemade steel. Paul Bigsby, a pattern maker from Downey, built Speedy a three-neck steel with four side-by-side foot pedals, a design that would later influence all pedal steel guitars. In 1948, Speedy was working at Murphy's Club on skid row in Los Angeles. There, he met Jimmy Bryant, who was playing at a nearby club. When Speedy heard Jimmy play guitar, he could not believe what he was hearing. That was the beginning of their long relationship. In 1949, Speedy began working as a full-time studio musician. He also played for Hank Penny, Cliffie Stone's Dinner Bell Round-Up, Hometown Jamboree, Tennessee Ernie Ford, Kay Starr, and other artists. (Courtesy of Marilyn Tuttle.)

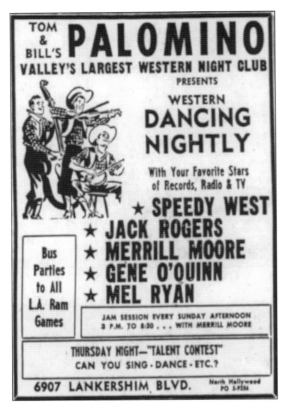

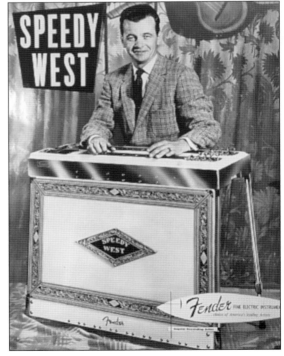

SPEEDY WEST AT THE PALOMINO CLUB. By 1960, there was a decline in country music session work around Los Angeles. Also, pedal steel guitar began to lose popularity in country recordings. In September 1960, Speedy moved from Southern California to Oklahoma. He worked for the Fender Musical Instruments Corporation as manager of its Tulsa warehouse. (Courtesy of *Billboard* magazine.)

SPEEDY WEST PLAYING FENDER STEEL GUITAR. While living in Tulsa, Speedy formed a band and played for several years around the area. In 1971, he moved to Broken Bow with his second wife, Mary. Following a stroke in 1981, Speedy was unable to play. However, he continued to attend steel guitar events. He died on November 15, 2003. (Courtesy of the Fender Musical Instruments Corporation.)

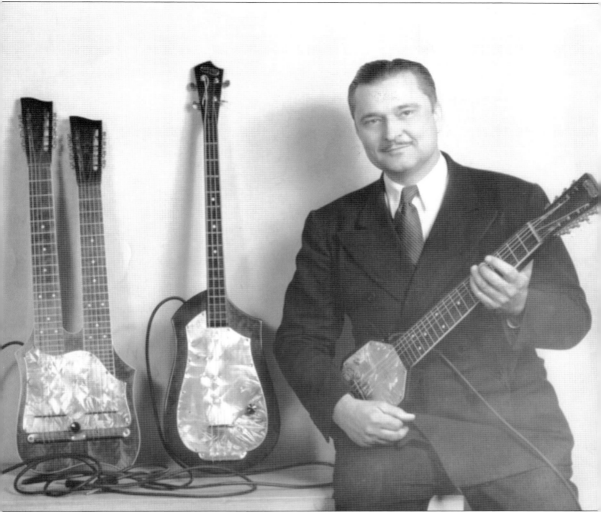

Bob Dunn. Robert Lee "Bob" Dunn (1906–1971) was born in Braggs, Oklahoma. In 1934, Dunn began playing a self-made electric steel guitar. That was three years before George Beauchamp was issued the first patent on an "electric stringed instrument." Dunn began playing with Milton Brown & His Musical Brownies in 1934. He was a pioneer in Western swing music. Dunn was the first steel guitar player to introduce jazz licks to country and Western music. (Courtesy of the Oklahoma Electric Cooperative.)

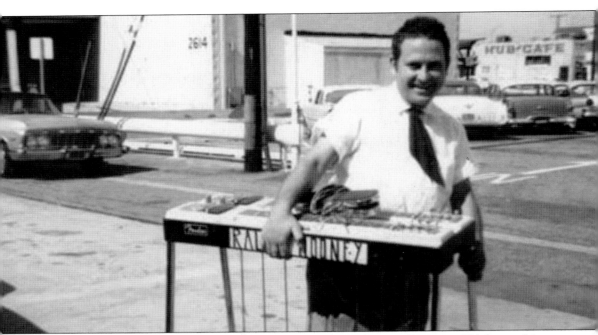

RALPH MOONEY. Ralph James Mooney (1928–2011) was born in Duncan, Oklahoma. Mooney performed on many of the original hit records that became known as the Bakersfield Sound. He played steel guitar for Wynn Stewart, Buck Owens, Merle Haggard, and Waylon Jennings. Mooney is also credited as the cowriter of "Crazy Arms," a country music standard made famous by Ray Price. Mooney said he wrote the song in 1949 while living in Las Vegas. The lyrics came to him after his wife left him because of his drinking problems. (Courtesy of Tyler Mahan Coe.)

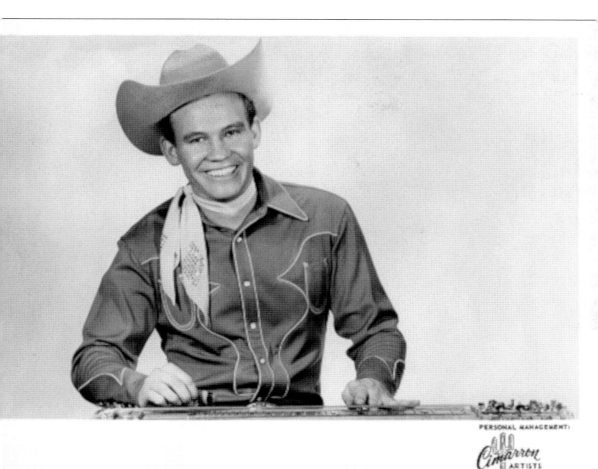

BOBBY WHITE

PERSONAL MANAGEMENT:

Cimarron
ARTISTS
TULSA, OKLAHOMA
CHerry 2-9181

BOBBY WHITE. Floyd L. "Bobby" White (1932–2003) played steel guitar with Bob Wills and His Texas Playboys. Around 1950, Bobby moved to Lawton, Oklahoma, where he met Hank Thompson. He soon became a member of Hank's Brazos Valley Boys, a group selected by *Billboard* magazine as the country music touring band of the year for 14 consecutive years. He is credited for pioneering the 10-string steel guitar. (Courtesy of Cimarron Artists.)

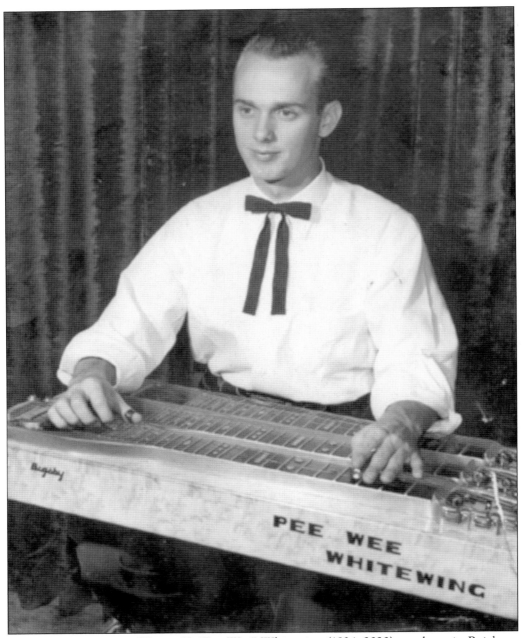

PEE WEE WHITEWING. Wayma K. "Pee Wee" Whitewing (1934–2020) was born in Reichert, Oklahoma. Pee Wee learned to play steel guitar when he was 10 years old. In 1951, he got a job for Blackie Crawford and the Western Cherokees. The group backed up Lefty Frizzell and Ray Price. In 1952, he became a member of Hank Thompson's Brazos Valley Boys. (Courtesy of hillbilly-music.com.)

Ten

PLACES OF
HISTORIC INTEREST

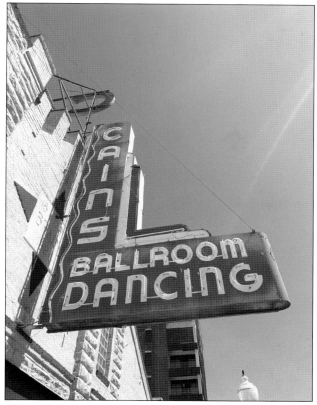

CAIN'S BALLROOM. Cain's Ballroom is a historic music venue located at 423 North Main Street in Tulsa, Oklahoma. The structure was built in 1924 as an automobile garage owned by Tate Brady, an entrepreneur, politician, and a founding father of the city. The building was sold to Madison "Daddy" Cain in 1930 and was renamed Cain's Dance Academy. Cain's originally operated as a dime-a-dance ballroom and dancing academy for the instruction of the waltz and Charleston. According to the Oklahoma Music Trail, "Cain's became the place to be, a venue to dance to cutting-edge music, to fall in love and to drink Prohibition-era bootleg whiskey purchased in the nearby alleyways." It soon became home to a new form of music known as Western swing. On January 1, 1935, Bob Wills made his debut at Cain's Ballroom. The venue became known as "the Home of Bob Wills" and the "Carnegie Hall of Western Swing." From 1935 to 1942, Bob Wills and His Texas Playboys performed at weekly dances.

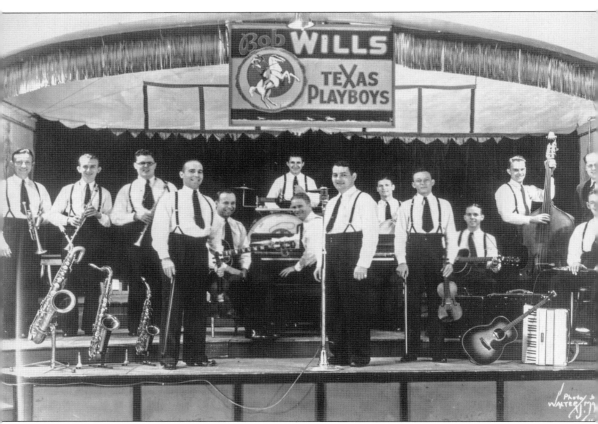

BOB WILLS AT CAIN'S BALLROOM. In 1943, Bob Wills moved to California. His brother, Johnnie Lee Wills, continued the weekly dances and radio broadcasts through the mid-1950s. Bob returned to Cain's Ballroom in 1957. However, the taste in music changed from Western swing to rock and roll. The legendary era defined by Bob Wills had come to an end. During the 1960s, Cain's was dormant. Larry Shaeffer purchased and reopened the club in 1977. Cain's has renewed its prominence as a concert venue in Tulsa. In 1978, the Sex Pistols performed at Cain's, and Sid Vicious allegedly punched a hole in the wall. Young artists continue to place their fists in the hole in homage to the Sex Pistols. Cain's Ballroom has a capacity of 1,800 and is known for its maple, spring-loaded dance floor designed in a "log cabin" pattern. A four-foot neon star and silver disco ball light the dance floor. The walls are decorated with photographs of entertainers who have performed at the historic club, including Bob Wills, Hank Williams, Kay Starr, and Ernest Tubb.

CHURCH STUDIO. The Church Studio was built in 1915 as the Grace Methodist Episcopal Church and changed several denominations over the years. The building is located at 304 South Trenton Avenue in Tulsa, situated in the Pearl District along Leon Russell Road. Leon Russell purchased the church in 1972 and converted the stone edifice into a world-class recording studio and home to Shelter Records. Russell owned the building for five years. It became renowned for historic recording and jam sessions that included artists such as J.J. Cale, Eric Clapton, Bob Dylan, George Harrison, Willie Nelson, and Tom Petty. The recording studio is situated in a large open area. It includes a control room with the original brick walls and church windows. During the years of ownership by Leon Russell and Shelter Records, the Church Studio became an epicenter of the Tulsa Sound—a laid-back combination of blues, country, rock and roll, and rockabilly. In 2016, the building was acquired by Tulsa entrepreneur Teresa Knox and her husband, Ivan Acosta. Their goal was to restore the building to the concept and creation of Leon Russell. The renovation took five years, and the studio was reopened in 2021 for music recording and as a concert venue, home to the Church Studio Archive, tourist attraction, and audio engineering school. (Courtesy of Teresa Knox.)

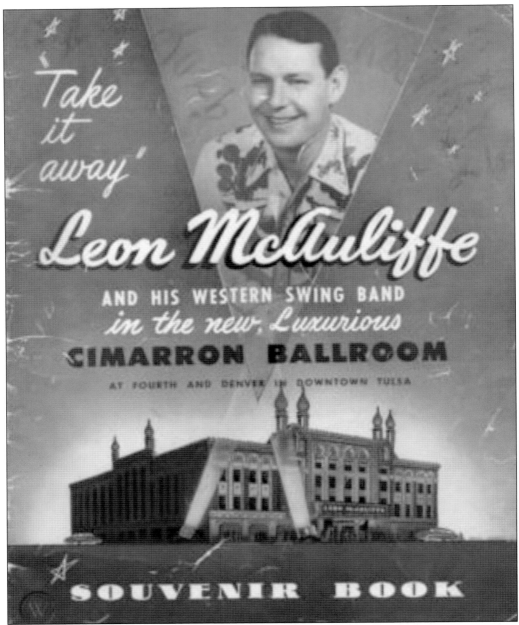

"Take it away" Leon McAuliffe AND HIS WESTERN SWING BAND in the new, Luxurious CIMARRON BALLROOM AT FOURTH AND DENVER IN DOWNTOWN TULSA SOUVENIR BOOK

CIMARRON BALLROOM. The Akdar Temple Theatre was a Tulsa landmark that opened in 1925. During the early 1950s, the Akdar was sold to Leon McAuliffe. He remodeled and renamed the building the Cimarron Ballroom. Leon & His Western Swing Band (later known as the Cimarron Boys) played at the 2,200-seat ballroom every Wednesday and Saturday evening. The Cimarron was demolished in 1973. The Cimarron Ballroom now consists of faded photographs and memories. A historic landmark was removed to make way for a bus station. It was a tragic end to a beautiful legacy. This story reminds everyone to protect the heritage and honor the legendary performers that paved the road that became the Oklahoma Music Trail.

BIBLIOGRAPHY

WEBSITES
Bob Wills. bobwills.com
Conway Twitty. conwaytwitty.com
Dallas Frazier. dallasfraziermusic.com (site discontinued)
Encyclopedia of Oklahoma History and Culture. https://www.okhistory.org/publications/
 encyclopediaonline
Find A Grave. findagrave.com
Gene Autry. geneautry.com
Hillbilly-Music dawt com. hillbilly-music.com
Jimmy Wakely. jimmywakely.wixsite.com (site discontinued)
Jimmy Webb: America's Songwriter. jimmywebb.com
Leon Russell: Master of Space and Time. leonrussell.com
Nashville Songwriters Hall of Fame. nashvillesongwritersfoundation.com
National Fiddler Hall of Fame. nationalfiddlerhalloffame.org
Oklahoma Music Trail. https://www.travelok.com/music-trail/
Patti Page. misspattipage.com (site discontinued)
Steel Guitar Hall of Fame. scottysmusic.com (site discontinued)

OKLAHOMA MUSEUMS
American Banjo Museum. americanbanjomuseum.com
Bob Dylan Archive. bobdylanarchive.com
Cain's Ballroom. cainsballroom.com
Gene Autry Oklahoma Museum. geneautryokmuseum.org
National Cowboy & Western Heritage Museum. nationalcowboymuseum.org
Oklahoma Country Western Museum & Hall of Fame. oklahomahof.com
Oklahoma Historical Society. okhistory.org
Oklahoma Jazz Hall of Fame. okjazz.org
Oklahoma Museum of Popular Culture. okpop.org
Oklahoma Music Hall of Fame. omhof.com
The Church Studio. thechurchstudio.com
Woody Guthrie Center. woodyguthriecenter.org

ORAL HISTORY
Country Music Hall of Fame and Museum. countrymusichalloffame.org
NAMM. namm.org
University of North Texas University Libraries. digital.library.unt.edu
Voices of Oklahoma. voicesofoklahoma.com

Discover Thousands of Local History Books
Featuring Millions of Vintage Images

Arcadia Publishing, the leading local history publisher in the United States, is committed to making history accessible and meaningful through publishing books that celebrate and preserve the heritage of America's people and places.

Find more books like this at
www.arcadiapublishing.com

Search for your hometown history, your old stomping grounds, and even your favorite sports team.

Consistent with our mission to preserve history on a local level, this book was printed in South Carolina on American-made paper and manufactured entirely in the United States. Products carrying the accredited Forest Stewardship Council (FSC) label are printed on 100 percent FSC-certified paper.

MADE IN THE USA